ANDY WARHOL

OCTOBER FILES

Rosalind Krauss, Annette Michelson, Yve-Alain Bois, Benjamin H. D. Buchloh, Hal Foster, Denis Hollier, and Mignon Nixon, editors

Richard Serra, edited by Hal Foster with Gordon Hughes
Andy Warhol, edited by Annette Michelson

ANDY WARHOL

edited by Annette Michelson

essays by Benjamin H. D. Buchloh, Thomas Crow, Hal Foster,
Annette Michelson, and Rosalind E. Krauss

OCTOBER FILES 2

The MIT Press
Cambridge, Massachusetts
London, England

This book was set in Bembo and Stone Sans by Graphic Compostion, Inc., and was printed and bound in the United States of America.

Library of Congress Cataloging-in-Publication Data

Andy Warhol / edited by Annette Michelson ; essays by Benjamin H. D. Buchloh . . . [et al.].
 p. cm. — (October files ; 2)
 Includes bibliographical references and index.
 ISBN 0-262-13406-3 (hc. : alk. paper) —ISBN 0-262-63242-X (pbk. : alk. paper)
 1. Warhol, Andy, 1928——Criticism and interpretation. I. Warhol,
Andy, 1928– II. Michelson, Annette. III. Buchloh, B. H. D. IV. Series.

N6537.W28 A788 2001
709'.2—dc21
 2001044026

Contents

OCTOBER Files addresses individual bodies of work of the postwar pe-
riod that meet two criteria: they have altered our understanding of art in
significant ways, and they have prompted a critical literature that is serious,
sophisticated, and sustained. Each book thus traces not only the develop-
ment of an important oeuvre but also the construction of the critical dis-
course inspired by it. This discourse is theoretical by its very nature, which
is not to say that it imposes theory abstractly or arbitrarily. Rather, it draws
out the specific ways in which significant art is theoretical in its own right,
on its own terms and with its own implications. To this end we feature es-
says, many first published in *OCTOBER* magazine, that elaborate differ-
ent methods of criticism in order to elucidate different aspects of the art in
question. The essays are often in dialogue with one another as they do so,
but they are also as sensitive as the art to political context and historical
change. These "files," then, are intended as primers in signal practices of art
and criticism alike, and they are offered in resistance to the amnesiac and
antitheoretical tendencies of our time.

The Editors of *OCTOBER*

Acknowledgments

"Andy Warhol's One-Dimensional Art: 1956–1966" by Benjamin H. D. Buchloh first appeared in *Andy Warhol: A Retrospective* (New York: Museum of Modern Art, 1989). "Saturday Disasters: Trace and Reference in Early Warhol" by Thomas Crow was previously published in Thomas Crow, *Modern Art in the Common Culture* (New Haven: Yale University Press, 1996). "Death in America" by Hal Foster first appeared in *October*, no. 75 (Winter 1996). "'Where Is Your Rupture?' Mass Culture and the *Gesamtkunstwerk*" by Annette Michelson first appeared in *October*, no. 56 (Spring 1991). "Carnal Knowledge" by Rosalind E. Krauss first appeared in *Andy Warhol: Rorschach Paintings* (New York: Gagosian Gallery, 1996). Benjamin Buchloh's interview with Andy Warhol took place May 28, 1985; it receives its first publication in this volume.

I wish to thank Steven Schneider and Koethi Zan for their generous and expert assistance.

ANDY WARHOL

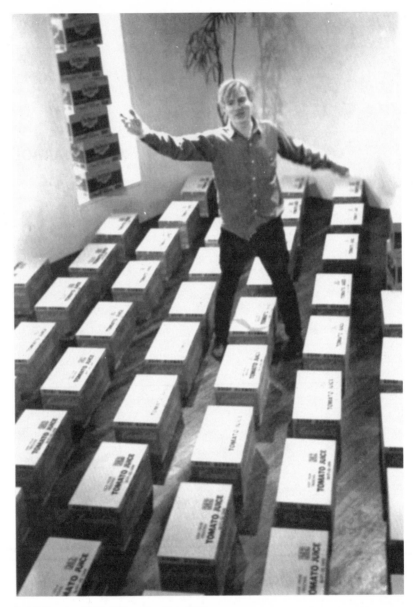

Installation view, Stable Gallery, New York, 1964.

Andy Warhol's One-Dimensional Art: 1956–1966

Benjamin H. D. Buchloh

If you want to know all about Andy Warhol, just look at the surface of my paintings and films and me, and there I am. There's nothing be-hind it.[1]

My work has no future at all. I know that. A few years. Of course my things will mean nothing.[2]

—Andy Warhol

A calling card designed by Andy Warhol on a scroll-size sheet of light green tissue paper, mailed to clients, patrons, and advertising and design agencies around 1955, depicts a circus *artiste* holding a giant rose. Her tightly cropped costume reveals her body to carry an overall tattoo featur-ing over forty corporate logotypes and brand names. Ranging from Arm-strong Tires to Wheaties, from Dow Chemicals to Pepsodent, the brands displayed on the body include Hunt's Tomato Catsup, which would liter-ally pop up as a three-dimensional can in *Andy Warhol's Index Book* in 1967, and Chanel No. 5 and the logo of the Mobil corporation, both of which would resurface thirty years later in his portfolio of silkscreen prints enti-tled *Ads.*[3]

The face of the *artiste* bears a single tattoo, ennobling her doll-like fea-tures with a laurel wreath wound around the majuscule L for Lincoln (the car). The costume's lower part, its slip, carries an inscription in the *faux naïf* script that had already endeared its author to his clients (ad men, women, and "art" directors), simply stating: *Andy Warhol Murry Hell 3-0555,* the artist's telephone number while he lived at 242 Lexington Avenue.[4]

Thus, even at the very beginning of his various careers, Andy Warhol literally "embodied" the paradox of modernist art, "to have a history at all

while under the spell of the eternal repetition of mass production," as Adorno put it. To be suspended between high art's haughty isolation (in transcendence, in resistance, in critical negativity) and the universally pervasive mass cultural debris of corporate domination constitutes the founding dialectic within the modernist artist's role. Its romantic origins and the final phase of its disappearance are invoked here with ironic sentiment in the reference to the *saltimbanque* muse and her corporate tattoos. That this dialectic constituting the production and reception of modernist art might originate in the collective disposition toward material objects at large, determined as it is in the act of consumption, has recently been suggested:

> With the aid of ideal types two distinct consumer styles may be seen emerging in the 1880s and the 1890s: an elitist type and a democratic one. For all their differences in detail, many, if not most, of the experiments in consumer models of those decades fall into one or the other of these categories. Both the elitist and the democratic consumers rebelled against the shortcomings of mass and bourgeois styles of consumption, but in seeking an alternative they moved in opposite directions. Elitist consumers considered themselves a new type of aristocracy, one not of birth but of spirit—superior individuals who would forge a personal mode of consumption far above the banalities of the everyday. Democratic consumers sought to make consumption more equal and participatory. They wanted to rescue everyday consumption from banality by raising it to the level of a political and social statement.[5]

Whether Warhol attempted to reconcile these contradictions in his own life by performing his professional role change from "commercial artist" to "fine artist" in 1960 remains a mystery.[6] By 1959 Warhol was, according to all evidence, a very successful professional in the field of advertisement design, earning an annual average of $65,000 accompanied by almost annual art directors' medals and other awards of professional recognition. As usual, Warhol's own commentaries on the world of commercial art and his motivation to abandon it construct a field of contradictory *blagues* that first of all bespeak the impertinence of the interviewer's (and by implication the viewers' and readers') inquisitiveness.

But already by 1954–1955 Warhol employed another kind of *blague* baring his ambitions toward the world of high art: in order to distinguish

himself within the mundane world of commercial design, he (fraudulently) claimed a high art success that he would actually attain only ten years later. In a folder produced around 1955 as a promotional gift for one of his patrons, the magazine *Vanity Fair,* on the occasion of Warhol's "Happy Butterfly Day," a discreet gold-stamped text on the inside informs us that "This Vanity Fair Butterfly Folder was designed for your desk by Andy Warhol, whose paintings are exhibited in many leading museums and contemporary galleries."[7] This reference to the museum as the ultimate institution of validation is still deployed thirty years later by Warhol (or on his behalf), in a rather different situation but for similar purposes.

Toward the end of his career, Warhol seems to have successfully integrated the two halves of the dialectic of consumption, his existence between what he once called "his favorite places to go to," the department store and the museum: the *1986 Christmas Book of the Neiman Marcus Stores* offers a portrait session with Andy Warhol for $35,000:

> Become a legend with Andy Warhol. . . . You'll meet the Premier Pop artist in his studio for a private sitting. Mr. Warhol will create an acrylic on canvas portrait of you in the tradition of his museum quality pieces.[8]

By contrast, on the occasion of his actual debut in the world of high art, when being presented in the special section of "Young Talent USA" in *Art in America* in 1962, Warhol (equally fraudulently) introduced himself as "self taught."[9]

Warhol's inversion of bluffs (the commercial world is bluffed with fine art legitimation, the high art world with brutish innocence) indicates more than a shrewd reading of the disposition of commercial artists to be eternally in awe and envy of the museum culture that they have failed to enter by producing mass cultural debris. Or, for that matter, its complementary formation, the disposition of the high art connoisseur to be eternally shocked into submission by anyone who claims to have truly broken the rules of high art's tightly determined and controlled discursive game. These strategically brilliant *blagues* (encoding the avant-garde's communication with its bourgeois audience, most aptly practiced by Baudelaire, Wilde, and Duchamp and brought up to late twentieth-century standards by Warhol) indicate Warhol's early awareness of the rapidly changing relationships between the two spheres of visual representation and the drastic changes of the artist's role and audience's expectations at the begin-

ning of the 1950s. Early on, he seems to have understood that it would be the task of the new generation of artists to recognize and publicly acknowledge how far the conditions that had allowed the formation of the abstract expressionist aesthetic along the parameters of romantic notions of heroic resistance and transcendental critique had actually been surpassed by the massive reorganization of society in the postwar period:

> It was the Second World War . . . which cut off the vitality of modernism. After 1945, the old semi-aristocratic or agrarian order and its appurtenances was [sic] finished in every country. Bourgeois democracy was finally universalized. With that, certain critical links with a pre-capitalist past were snapped. At the same time, Fordism arrived in force. Mass production and mass consumption transformed the West European economies along North American lines. There could no longer be the smallest doubt as to what kind of society this technology would consolidate: an oppressively stable, monolithically industrial, capitalist civilization was now in place.[10]

This new civilization would create conditions in which mass culture and high art would be forced into an increasingly tighter embrace, eventually leading to the integration of the sphere of high art into that of the culture industry. But this fusion would not just imply a transformation of the artist's role and changing cultural practices; it would also affect images and objects and their services and functions inside society. The real triumph of mass culture over high culture would eventually take place—quite unexpectedly for most artists and critics—in the functions that a fetishized concept of high art would assume in the larger apparatus of ideology.

Allan Kaprow, one of the more articulate members of that new generation of postwar artists, would grasp this transformation of the artistic role a few years later:

> It is said that if a man hits bottom there is only one direction to go and that is up. In one way this has happened, for if the artist was in hell in 1946, now he is in business. . . . There is a chance that the modern "visionary" is even more of a cliché than his counterpart, the "conformist," and that neither is true.[11]

As his calling card suggested, Warhol was uniquely qualified to promote the shift from visionary to conformist and to participate in this transition

from hell to business: after all, his education at the Carnegie Institute of Technology, from which he graduated in 1949, had not been a traditional fine arts studio education and had provided him with a depoliticized and technocratically oriented American version of the Bauhaus curriculum as it had spread rapidly in the postwar years from László Moholy-Nagy's New Bauhaus in Chicago through numerous American art institutions.[12]

In fact, when reading early interviews with Andy Warhol, one can still come across the egalitarian and democratic traces of that populist modernist credo that seems to have motivated Warhol (and pop art in general) at the initial stage of his development. Questions both of production and reception seem to have concerned him. For example, in a little-known interview from the mid-1960s:

> Factory is as good a name as any. A factory is where you build things. This is where I make or *build* my work. In my art work, hand painting would take much too long and anyway that's not the age we live in. Mechanical means are *today,* and using them I can get more art to more people. Art should be for everyone.[13]

Or when addressing the question of audiences for his work, in one of his most important interviews in 1967:

> Pop art is for everyone. I don't think art should be only for the select few, I think it should be for the mass of American people and they usually accept art anyway.[14]

One of the first corporate art sponsors and one of the major supporters of Moholy-Nagy's Chicago projects at the Institute of Design (1938–1946), as well as a fervent advocate of the industrialization of modernist aesthetics in the United States, was Walter Paepcke, the president of the Container Corporation of America. Paepcke had anticipated the successful synthesis of modernism's conflicting halves impatiently (and prematurely) in 1946. To Paepcke—and many others—mass culture and high art would have to be reconciled in a radically commercialized Bauhaus venture. Purged of the political and ideological idea that artistic intervention in the spheres of production and consumption would enable collective social progress, the cognitive and perceptual devices of modernity would have to be deployed simply for the development of a new commodity aesthetic (e.g., product design, packaging, and advertisement). The fabrica-

tion of that aesthetic would, in fact, become one of the most powerful
and important industries in postwar America and Europe, without, how-
ever, resolving the contradictions of modernism.

Here are the words of the visionary from the other side:

> During the last century in particular, the Machine Age with its mass
> production procedures has seemingly required specializations which
> have brought about an unfortunate divergence in work and philos-
> ophy of the individual producer and the artist. Yet artists and business
> men, today as formerly, fundamentally have much in common and can
> contribute the more to society as they come to complement their tal-
> ents. Each has within him the undying desire to create, to contribute
> something to the world, to leave his mark upon society.[15]

The reasoning of this dogged entrepreneurial vision in 1946 would find
its farcical echo thirty years later in Warhol's triumphant proclamation of
diffidence at a moment when—in accordance with the institutional and
commercial policies of the cultural apparatus—he had replaced even the
last remnants of an aesthetic of transcendence or critical resistance by an
aesthetic of ruthless affirmation:

> Business art is the step that comes after Art. I started as a commercial
> artist, and I want to finish as a business artist. After I did the thing
> called "art" or whatever it's called, I went into business art. I wanted to
> be an Art Businessman or a Business Artist. Being good in Business is
> the most fascinating kind of art.[16]

That triumph of mass culture over traditional concepts of aesthetic tran-
scendence and critical resistance would produce two new *types* of "cul-
tural" personalities: the first one being the ever-increasing number of ad
men who would become passionate collectors of avant-garde art (in order
to buy off and embrace the "creativity" that would perpetually escape
them, in order to possess privately what they would systematically destroy
by their own "work" in the public sphere).

The other type consisted of the hundreds and hundreds of artists such
as one James Harvey, who, according to *Time* magazine,

> draws his inspiration from religion and landscapes. . . . At nights he
> works hard on muscular abstract paintings that show in Manhattan's

Graham Gallery. But eight hours a day, to make a living, he labors as a commercial artist.[17]

When Harvey, who had designed the actual Brillo box in the early 1960s, encountered his design on 120 wooden simulacra made by Andy Warhol (or his assistants) for his second show at the Stable Gallery in New York in 1964—declared to be an exhibition of contemporary high art—he could only deflect his sense of a profound crisis concerning the standards of artistic culture into threatening Warhol with a sort of paternity suit concerning the originality of the box's design.

Andy Warhol, by contrast, was fairly well prepared to reconcile the contradictions emerging from the collapse of high culture into the culture industry and to participate in it with the skills and techniques of the commercial artist. He had freed himself early on from obsolete concepts of originality and authorship and had developed a sense of the necessity for "teamwork" and "collaboration" and a Brechtian understanding of the commonality of "ideas"—those universally prevailing forms of social production from which, traditionally, only the specialized and condensed talent of the artist as unique and singular creator had been exempted.[18]

Commercial Folklore

In his transition from one role to the other, Warhol seems to have lived through every stage of the paradox of this division of high culture from mass culture and their eventual fusion. During his early career as a commercial artist, he featured all those debased and exhausted qualities of the traditional concepts of the "artistic" that art directors and ad men then would still have adored—that is, the whimsical and the witty, the wicked and the *faux naïf*, precisely those qualities that Warhol's *artiste* had advertised in the promotional calling card from *Murry Hell*. In Warhol's early work—as had already been the case in 1920s art deco advertisement, packaging, and book illustration—one of the resources for such an artistically contrived realm of unbridled pleasure before/beyond mechanization would be the aristocratically refined preindustrial charms of rococo and neoclassical drawing. The other resource of noncommercial charm would be that particular variety of (American) folk art with which dozens of artists in the American context since Elie Nadelman had identified, if only as collectors. After all, the folk art object, with its peculiar form of an already extinct creativity, seemed to mirror the disappearance of the tra-

ditional type of artistic creativity, which these artists eventually would have
to face themselves.

Warhol's success as a commercial designer depended in part on this
"artistic" performance, on his delivery of a notion of creativity that was
bound to appear all the more rarefied in a milieu whose every impulse is
geared to increase the efficacy of commodification and the professional
eradication of individual subjectivity in the realm of public (and private)
perceptual experience. With a collector's condescending love for the spec-
imens of an extinct species, Warhol introduced precisely those practices
(the false naiveté, the charm of the uneducated and unskilled, the prein-
dustrial *bricolage,* his illiterate mother) into the most advanced and most so-
phisticated milieu of professional alienation: advertisement design.

Warhol was fully aware of this paradox. In his famous early interview
with Gene R. Swenson he phrased it in a language that reveals to what ex-
tent its speaker had internalized the lessons of John Cage and transposed
them even further onto the level of everyday experiences:

> It's hard to be creative and it's hard also not to think what you do is
> creative or hard not to be called creative because everybody is always
> talking about that and individuality. Everybody's always being cre-
> ative. And it's so funny when you say things aren't, like the shoe I
> would draw for an advertisement was called a "creation" but the draw-
> ing of it was not. But I guess I believe in both ways. . . . I was getting
> paid for it, and I did anything they told me to do. . . . I'd have to in-
> vent and now I don't; after all that "correction" those commercial
> drawings would have feelings, they would have a style. The attitude of
> those who hired me had feeling or something to it; they knew what
> they wanted, they insisted, sometimes they got very emotional. The
> process of doing work in commercial art was machine-like, but the at-
> titude had feeling to it.[19]

By contrast, Warhol's successful debut as an artist in the sphere of high
art—and here the paradox becomes fully apparent—would depend pre-
cisely on his capacity to erase from his paintings and drawings more com-
pletely than any of his peers or immediate predecessors (Jasper Johns and
Robert Rauschenberg, in particular) the traces of the handmade, of
artistry and creativity, and of expression and invention.

What appeared to be cynical, mere copies of commercial art, early in
1960 inevitably had to scandalize then still dominant art world expecta-

tions (and self-deceptions). At the climax of the reception of abstract expressionism, this art would shock all the more because the public's eyes were unfamiliar with or had conveniently disavowed the work of Picabia's mechanical period, for example, or had preferred to ignore the implications of Duchamp's readymades.

The notorious anecdote of Warhol's showing two versions of a painting of a Coca-Cola bottle to his friend Emile de Antonio in 1962—one gesturally dramatic and carrying the legacy of abstract expressionism; the other cold and diagrammatic, claiming the rights of the readymade in the domain of painting—not only attests to Warhol's uncanny ability to produce according to the needs and demands of the moment (and to his technical skills to perform these tasks). It also seems to betray a brief instance of hesitation in Warhol's calculation of how far he could really go with the breakdown of local painterly conventions and the infusion of commercial design devices in order to make his entry in the New York high art world. After all, as late as July 1962, Warhol's first New York exhibition project arranged with the prestigious Martha Jackson gallery had been canceled with the following argument:

> As this gallery is devoted to artists of an earlier generation, I now feel I must take a stand to support their continuing efforts rather than confuse issues here by beginning to show contemporary Dada. . . . The introduction of your paintings has already had very bad repercussions for us. This is a good sign, as far as your work and your statement as an artist are concerned. Furthermore, I like you and your work. But from a business and gallery standpoint, we want to take a stand elsewhere. Therefore, I suggest to you that we cancel the exhibition we had planned for December 1962.[20]

Apparent lack of painterly resolution, often misread as parodic mockery of abstract expressionism, is persistent throughout Warhol's early work between 1960 and 1962, pictures painted in a loose, gesturally expressive manner but whose imagery is derived from close-up details of comic strips and advertisement fragments.[21] De Antonio, identified as a Marxist in Warhol's recollections, gave him the right advice (and so did Ivan Karp, the dealer, who saw both paintings as well): to destroy the abstract expressionist Coca-Cola bottle and keep the "cold" diagrammatic one.[22]

What is most obvious in these early hand-painted paintings of logotypes and diagrams (especially evident when Warhol kept both versions, as

in *Storm Window I* and *Storm Window II,* or *Before and After I, II, III*) is that Warhol's expertise and technical skills as a commercial artist qualified him for this diagrammatic design of the new painting, in the same manner that his traditional artistic inclinations had once qualified him for success in the world of commercial design.

It has frequently been argued that there is very little continuity between Warhol the "commercial" artist and Warhol the "artist."[23] However, a more extensive study of Warhol's advertisement design would in fact suggest that the key features of his work of the early 1960s are prefigured in the refined arsenal and manual competence of the graphic designer: extreme close-up fragments and details, stark graphic contrasts and silhouetting of forms, schematic simplification, and most important, of course, rigorous serial composition.

That sense of composing depicted objects and arranging display surfaces in serially structured grids emerges after all from the serial condition that constitutes the very "nature" of the commodity in all its aspects: its *object status,* its *design,* and its *display.* As such, seriality had become the major structural formation of object perception in the twentieth century, determining aesthetic projects as different as that of Siegfried Kracauer and Walter Benjamin on the one hand and Busby Berkeley on the other. Amédée Ozenfant had rightfully included serial commodity display in his *Foundations of Modern Art* in 1931. By the mid-1950s, the serial grid composition had reemerged with the prominence it had already acquired in the 1920s: Ellsworth Kelly's serial arrangement of monochrome display panels, such as *Colors for a Large Wall* (1951–1952), like Jasper Johns's *Gray Alphabets* (1956), for example, prefigure the central strategy of Warhol's compositional principle to the same extent in the American context, while the serially structured arrangements of readymade objects by Arman had concretized this strategy in the European context of the late 1950s—all of them certainly known to Warhol from exhibitions and magazine reproductions of that period.

And of course, the opposite is true as well: that Warhol's real affinity for and unusual familiarity (for a commercial artist) with the advanced avant-garde practices of the mid-1950s, in particular the work of Johns and Rauschenberg, inspired his advertisement design of that period and imbued it with a *risqué* stylishness that the average commercial artist, lacking a real understanding of the formal and strategic complexity of the work of these artists, would have been unable to conceive. Two outstanding examples from Warhol's campaigns for I. Miller Shoes in the *New York*

Times from 1956 confirm that he had already grasped the full range of the painterly strategies of Johns and Rauschenberg—in particular those aspects that would soon determine his own pictorial production. The first piece features the careful overall regularization of a nonrelational composition (as in the obvious example of Johns's *Flag* paintings since 1954), a strategy that would soon be mechanically debased in Warhol's hands and be depleted of all of Johns's culinary painterly differentiation. The second example shows the impact of Rauschenberg's direct imprinting techniques and persistent use of indexical mark-making since his collaboration with John Cage on the *Tire Print* in 1951, a method that Warhol would soon void of all expressivity and the decorative artistry it had gradually regained in Rauschenberg's ever more aestheticizing skills of the later 1950s.

The Rituals of Painting

It appears then that by the end of the 1950s Warhol, both commercially competent and artistically canny, was singularly prepared to perform the historically necessary transformation of the artist's role in the American post–World War II context, the transformation of an aesthetic practice of transcendental negation to one of tautological affirmation, best articulated in John Cage's famous dictum: "Our poetry now is the realization that we possess nothing. Anything therefore is a delight (since we do not possess it . . .)." That this transformation would concretize itself as well in rethinking, if not in altogether dismantling, the traditional format of easel painting had already been predicted in 1958 in a text that seems to have functioned as the manifesto of the new generation of American artists after abstract expressionism, that is, Allan Kaprow's essay "The Legacy of Jackson Pollock":

> Pollock's near destruction of this tradition [of easel painting] may well be a return to the point where art was more actively involved in ritual, magic and life than we have known it in our recent past. If so, it is an exceedingly important step, and in its superior way, offers a solution to the complaints of those who would have us put a bit of life into art. But what do we do now? There are two alternatives. One is to continue in this vein. . . . The other is to give up the making of paintings entirely.[24]

In spite of Kaprow's acumen and his prognostic observations, the essay is

also marred by two fundamental misunderstandings. The first is the idea that the hegemony of abstract expressionism had come to an end because Pollock, in Kaprow's words, "had destroyed painting" and because of the vulgarization of the abstract expressionist style by its second-generation imitators. This assumption suggests—as historians and critics have argued ever since—that a mere stylistic rebellion against New York School painting and its academization was the major motivating force in the formation of pop art.[25]

This stylistic argument, descriptive at best, eternally mistaking the effects for the cause, can be most easily refuted by two historical facts: first, that painters such as Barnett Newman and Ad Reinhardt only received their real recognition as late as the mid-1960s and that Willem de Kooning and Mark Rothko continued to work with ever-increasing visibility and success. If anything, by the mid-1960s their work (and most certainly Pollock's) had achieved an almost mythical status, representing aesthetic and ethical standards that seemed, however, definitely lost and unattainable for the future. Secondly, the younger generation of New York School artists, from Johns and Rauschenberg to Claes Oldenburg and Warhol, continuously emphasized their affiliation with and veneration of the legacy of abstract expressionism in both their works and their statements, but they equally emphasized the impossibility of achieving, let alone continuing, their transcendental artistic aspirations and standards.

The second (and major) misconception in Kaprow's essay becomes evident in the contradictory remarks on the revitalization of the artistic ritual and the simultaneous disappearance of easel painting. Kaprow conceives of the ritualistic dimension of aesthetic experience (what Walter Benjamin had called the "parasitical dependence of art upon the magic ritual") as a stable and transhistorical, universally accessible condition that could be reconstituted at all times by merely altering the exhausted stylistic means and obsolete artistic procedures, by innovating pictorial iconography and modes of artistic production. Like Benjamin in the 1920s when he developed the notion of a participatory aesthetic in the context of his discussion of dadaism, Kaprow in 1958 still speaks with an astonishing enthusiasm and naiveté about the historical possibility of a new participatory aesthetic emerging out of Pollock's work:

> But what I believe *is* clearly discernible is that the *entire* painting comes out at the participant (I shall call him that, rather than observer) right into the room. . . . In the present case the "picture" has moved

so far out that the canvas is no longer a reference point. Hence, although up on the wall, these marks surround us as they did the painter at work, so strict a correspondence has there been achieved between his impulse and the resultant art.[26]

In fact, what *would* occur in the formation of pop art in general and Warhol's work in particular turned out to be the absolute opposite of Kaprow's emphatic prophecy: the "destruction" of painting, as initiated by Pollock, would be accelerated, and it would be extended to comprise now also the destruction of *the last vestiges of the ritual* in aesthetic experience. Warhol would come closer than anybody since Duchamp (in the Western European and American avant-garde, at least) "to [giving] up the making of painting entirely." What was more, Warhol's "paintings" would oppose those aspirations toward a new (and historically naive) aesthetic of participation (as it had been preached and practiced by Cage, Rauschenberg, and Kaprow) by degrading precisely those notions to the level of absolute farce. *Tango,* for example, had been the title of one of Jasper Johns's crucial monochromatic and participatory paintings in 1955, programmatically embodying the Cagean concept of participation in its invitation to the viewer to wind up the painting's built-in music box. Johns explicitly stated that such a participatory concept motivated his work at the time:

> I wanted to suggest a physical relationship to the pictures that was active. In the *Targets* one could stand back or one might go very close and lift the lids and shut them. In *Tango* to wind the key and hear the sound, you had to stand relatively close to the painting, too close to see the outside shape of the picture.[27]

Seven years after Johns's *Tango* and four years after Kaprow's prophetic text, Andy Warhol would produce two groups of diagrammatic paintings, the two *Dance Diagrams* (*Fox Trot* and *Tango*) and the series of five *Do It Your-self* paintings (and a number of related drawings). These works seem to have been conceived in direct response to the historical status (and the impossibility) of renewing the concept of participatory aesthetics, if not in direct response to Johns's and Rauschenberg's paintings or even in a spirit of rebuttal of the euphoric optimism of Kaprow's manifesto.

Both types of painting inscribe the viewer literally, almost physically, into the plane of visual representation in what one could call a "bodily synecdoche"—a heroic tradition of twentieth-century avant-garde prac-

tice that would instigate active identification of the reader/viewer with the representation and replace the passive contemplative mode of aesthetic experience by an activating participatory mode. However, this tradition had, in the meantime, become one of the strategies, if not *the* key strategy, of advertisement design itself, soliciting viewers' active participation as *consumption*.

Accordingly, in Warhol's paintings, the diagrams that would entangle viewers' feet in the *Dance Diagram* paintings and engage viewers' hands in the *Do It Yourself* paintings are frivolously transferred onto the pictorial plane of high art from the domains of popular entertainment rituals (fox trot, tango, etc.), which were slightly camp and defunct at that. What is more, they seem to suggest that if "participatory aesthetics" in high art practice had reached that level of infantilizing interaction, restricting the potential participants to winding up a music box, clapping their hands, or hiding an object—as suggested in some of Johns's and Rauschenberg's works—one might just as well shift from the strategic games of high art to those *real rituals of participation* within which mass culture contains and controls its audiences.

This dialogic relationship of the *Dance Diagram* paintings with Kaprow's "The Legacy of Jackson Pollock" and the status of participatory aesthetics was made even more explicit in Warhol's rather peculiar decision to present these paintings in their first public installation horizontally on the floor, making the display an essential element of the painting's reading.[28] Simulating the function of actual "diagrams" for steps to be taken on the floor, they not only increased the facetious invitation to the viewer to participate in a trivial ritual of mass culture, but they literally parodied the position of the painting in Pollock's notorious horizontal working procedure, as it had been described in Harold Rosenberg's famous 1952 essay "The American Action Painters" (which still reverberated through Kaprow's manifesto as well):

> At a certain moment the canvas began to appear to one American painter after another as an arena in which to act—rather than as a space in which to reproduce, re-design, analyze or "express" an object, actual or imagined. What was to go on the canvas was not a picture but an event. . . . The image would be the result of this encounter.[29]

The destruction of the painterly legacy of Jackson Pollock and the critique of a remedial reconstruction of aesthetic experience as participatory

ritual would resurface in Warhol's work once again almost twenty years later. Precisely at the moment of the rise of neo-expressionism, Warhol delivered one of his last *coups* to an increasingly voracious high culture industry desperately trying to revitalize the expressionist paradigm and its failed promises.

His series of *Oxidation* paintings (1978), whose monochrome surfaces were coated with metallic bronze paint, were striated and spotted with the expressively gestural oxidizing marks of the author's (or his assistants') urination on the canvas; they brought to a full cynical circle the critique that had begun in the *Dance Diagrams'* original parody of the ritual.

The Monochrome

Two other important aspects—mechanically reproduced readymade imagery and monochromatic color schemes—are evident already in the *Dance Diagrams* in 1962. They will become, along with the principle of serial grid composition, the central strategies of Warhol's entire painterly production.

Warhol's "discovery" of the modernist tradition of monochrome painting, frequently concealed in metallic monochrome sections of the paintings or blatant in separate panels (the "blanks" as he called them, with a typically derogatory understatement), aligns his painterly work of the early 1960s in yet another way with some of the key issues emerging from New York School painting.

Pollock had notoriously included industrial aluminum paint in his key paintings of the late 1940s, such as *Lucifer* (1947) or *Lavender Mist* (1950), and the painterly matter's industrial—as opposed to fine art—derivation had generated a visual "scandal," while its (relative) light reflectivity concretized the viewer's optical relationship to that matter in a literalist, almost mechanical manner. Warhol deployed the same industrial enamel, and his use of aluminum paint would only be the beginning of a long and continuously intensifying involvement with "immateriality," both that of light reflectivity and that of "empty" monochrome surfaces. Evolving from the various stages of gold and silver *Marilyns* in 1962, followed by the silver series of *Elvis Presley* and numerous other paintings silkscreened on silver planes throughout 1963 to 1964 (*Marlon Brando, Tunafish Disaster, Thirteen Most Wanted Men*), Warhol produced the first diptych paintings with large-size monochrome panels in 1963 (*Mustard Race Riot, Blue Electric Chair*)

and the first monochrome metallic diptychs in 1964 (*Round Jackies*) and the silver *Liz* diptych in 1965.

As was the case with the *Dance Diagrams* and the *Do It Yourself* paintings, the monochrome diptychs performed a complete devaluation and inversion of one of the most sacred modernist pictorial strategies that had originated in symbolist sources. Upon its arrival in the twentieth century, it had been hailed by Wassily Kandinsky in 1911 in the following terms:

> I always find it advantageous in each work to leave an empty space; it has to do with not imposing. Don't you think that in this there rests an eternal law—but it's a law for tomorrow.[30]

That "empty space," as Kandinsky's statement clearly indicates, was conceived of as yet another strategy of *negation,* negating aesthetic imposition, functioning as a spatial *suture* that allowed the viewer to situate himself or herself in a relationship of mutual dependence with the "open" artistic construct. The empty space functioned equally as a space of hermetic *resistance,* rejecting the assignment of ideological meaning and the false comforts of convenient readings alike. It was in those terms and certainly with those aspirations that the monochrome strategy had been deployed by both Newman and Reinhardt throughout the 1950s into the early 1960s, imbuing their monochrome paintings (and the strategy itself) paradoxically with a renewed sense of transcendental sacrality reminiscent of its symbolist origins.

On the other hand, like all other modernist strategies of reduction, the monochrome easily approached the very threshold where sacrality inadvertently turned into absolute triviality, whether as the result of incompetent execution of such a device of apparently supreme simplicity, or from the effect of exhausting a strategy by endless repetition, or as an effect of the artists' and viewers' growing doubts about a strategy whose promises and pretenses had become increasingly incompatible with its actual physical and material object status and functions (for example, Rothko's refusal to supply the meditative panels for the Seagram corporate dining room).[31]

Already looking back on an established set of practices that had performed the critical inversion of the modernist paradigms of hermetic seclusion and reduction, Allan Kaprow in 1964 cites "the blank canvas" among these critical acts in which the elitist hermeticism and the metaphysical claims of monochromy had been revised:

Pursuit of the idea of "best" becomes then (insidiously) avoidance of the idea of "worst" and Value is defeated by paradox. Its most poignant expressions have been the blank canvas, the motionless dance, the silent music, the empty page of poetry. On the edge of such an abyss all that is left to do is *act*.[32]

This process of a critical reevaluation of that tradition had begun once again in the American context in Rauschenberg's early *White Paintings* (1951) and would find its climax (along with the official termination of Warhol's painterly production) in the silver mylar pillows—identified by Warhol as "paintings"—inflated with helium, floating through (and supposedly out of) the Leo Castelli Gallery in 1966. Shortly before, Warhol had publicly announced that he had abandoned painting once and for all, leading as it seemed into the vicinity of Kaprow's envisioned "action," yet typically refraining from it.[33] Warhol's more skeptical evaluation of the historically available options for cultural practices would prove Kaprow's prophecies once again to be falsely optimistic.

Thus, the monochrome field and the light-reflective surface, seemingly emptied of all manufactured visual incident, had become one of the central concerns of the neo-avantgarde artists of the early to mid-1950s, as evident not only in Rauschenberg's work but equally in the work of Kelly and Johns (and, a few years later, in that of Frank Stella) as much as in the work of their European contemporaries Lucio Fontana and Yves Klein.

Rauschenberg, for one, had done a series of small square collages with gold and silver leaf in 1953, which he had exhibited at the Stable Gallery that year. He continued through 1956 to use the crumpled foil on roughly textured fabric, a combination that eliminated drawing and gesture and instead generated surface and textural incident exclusively from within the material's inherent qualities and procedural capacities. Frank Stella, before engaging in his series of large aluminum paintings in 1960 (the square paintings *Averroes* and *Avicenna,* for example), had already produced a group of smaller square paintings in 1959, such as *Jill,* that were covered with geometrically ordered, highly reflective metallic tape (as opposed to Rauschenberg's randomly broken and erratically reflecting foil surfaces).

Warhol has explicitly stated that this legacy of monochrome paintings of the early to mid-1950s influenced his own decision to paint monochrome panels in the early 1960s. For example, Warhol said of Ellsworth Kelly:

I always liked Ellsworth's work, and that's why I always painted a blank canvas. I loved that blank canvas thing and I wished I had stuck with the idea of just painting the same painting like the soup can and never painting another painting. When someone wanted one, you would just do another one. Does anybody do that now? Anyway, you do the same painting whether it looks different or not.[34]

In spite of Warhol's typically diffident remarks about the historical references for his use of monochrome panels, the flippancy quite clearly also indicates his awareness of the distance that separates his conception of the monochrome from that of Kelly. Recognizing that not a single strategy of modernist reduction, of radical negation and refusal, could escape its ultimate fate of enhancing the painting's status as object and commodity, Warhol in his use of monochromy in the early 1960s seems to have set himself the task of destroying any and all metaphysical residue of the device (be it in neoplasticist, abstract expressionist, or, as it was identified, hard edge and color field painting of the 1950s). It seems possible therefore to argue that Warhol's earliest paintings explicitly inscribed themselves into that venerable legacy, and that paintings such as *Yellow Close Cover before Striking* (1962) or *Red Close Cover before Striking* (1962) perform the same critical inversion with regard to the color field legacy and the work of Barnett Newman, for example, as the *Dance Diagrams* and the *Do It Yourself* paintings had with "the legacy of Jackson Pollock."

And once again it is through Warhol's uncompromising negation, through his absolute contamination of the elusive hermeticism of the monochrome with the vulgarity of the most trivial of commonplaces (in this case, the diagrammatic detail of the sulfur strip of a matchbook cover), that his work performs the task of that destruction most convincingly, making it the realization of an inevitable external condition, not an individual assault on a venerated pictorial tradition.

As had been the case with his assault on the ritualistic legacy of abstract expressionism, Warhol knew early on that this process would eventually dismantle more than just the strategy of the monochrome itself. Any consequential implementation of the modernist strategy of the monochrome would at this point inevitably lead to a different spatial definition (not to say dissipation) of painting in general, thereby removing it from any traditional conception of a painting as a substantial, unified, integrated planar object, whose value and authenticity are as much consti-

tuted and contained in its status as a uniquely crafted object as they are guaranteed in its modes of display and the readings ensuing from these conventions.[35] In a little-known interview from 1965, Warhol commented on these aspects:

> You see, for every large painting I do, I paint a blank canvas, the same background color. The two are designed to hang together however the owner wants. He can hang it right beside the painting or across the room or above or below it. . . . It just makes them bigger and mainly makes them cost more. *Liz Taylor,* for instance, three feet by three feet, in any color you like, with the blank costs $1600—signed of course.[36]

Readymade Imagery

Warhol's "found" representations and their diagrammatic nature departed from the paradox that the more unmediated and spontaneous pictorial mark-making had become in Pollock's work (supposedly increasing the veracity and immediacy of gestural expression), the more it had acquired the traits of depersonalized mechanization.

Painterly execution since Pollock therefore seemed to have constantly shifted between the ritualistic performance of painting (to which Rosenberg's and Kaprow's readings had aspired) and the recognition that his painting had thrived on a profoundly antipainterly impulse. This promise of a mechanistic anonymity within the process of pictorial mark-making, however, not only seemed to imply the eventual "destruction" of painting proper (as Kaprow had anticipated as well) but had also brought it (much less dramatically) into historical proximity with the postcubist devices of antipainterly strategies and readymade imagery—a proximity that Pollock himself had reached in works such as *Out of the Web (Number 7)* (1949) or *Cut Out* (1949). If that anti-artistic and anti-authorial promise (and the rediscovery of that promise's historical antecedents) had perhaps not yet been fulfilled in Pollock's own work, it had certainly become foregrounded with ever-increasing urgency in the responses that Pollock's work had provoked in Rauschenberg's and Johns's painting of the early to mid-1950s. Rauschenberg, for example, had made this evident as early as 1948 to 1949 in his *Female Figure (Blueprint),* rediscovering one of the conventions of readymade imagery—the immediate (indexical) imprint of

the photogram and rayogram—and enlisting it in the services of New York School painting.[37] Furthermore, he challenged traditional concepts of authorial authenticity and sublime expressivity in his collaboration with John Cage in 1951 on the *Automobile Tire Print,* in his *Erased de Kooning Drawing* in 1953, and, most programmatically, of course, in his major assault on painterly presence in the seemingly devalidating and repetitious *Factum I* and *Factum II* in 1957. Johns, perhaps even more programmatically, had reestablished these parameters not only in his direct casting methods, which he had derived from Duchamp, but equally so in his stenciled, collaged, and encaustic paintings since 1954.[38]

One should realize therefore that Warhol's radical mechanization of the pictorial mark-making process, apparently scandalous at the time, drew in fact on a fully developed tradition. This tradition ranged from the work of the key figures of New York Dada—Man Ray's *Rayograms* and Francis Picabia's engineering diagrams from his mechanical period—to Rauschenberg's and Johns's work of the early to mid-1950s, when the rediscovery of those precedents of readymade imagery and indexical procedures had been inscribed into the legacy of New York School painting. In light of this range of previously established techniques to apply and repeat mechanically factured pictorial marks, the frequently posed question of whether it was Rauschenberg or Warhol who first used the silkscreen process in painting is utterly futile.

Warhol's mechanization—at first timid and unresolved, as we saw in his earliest paintings which still adhered to the manual gesture—developed at first gradually (and then rapidly) from 1960 to 1962 and led from the hand-painted diagrams through the rubber stamps and stencil paintings in 1961–1962 to the first fully silkscreened canvases of Troy Donohue, Marilyn Monroe, and Elvis Presley, which had already been shown—along with *Tango*—in his first New York exhibition.

The historical difficulty that Rauschenberg and Johns had to overcome, however, was that the local preeminence of abstract expressionist painting and its definitions of mark-making as expressive gestural abstraction had not only completely obliterated those conventions but had also required that, in order to be "seen" or "legible" at all in 1954, one had to inscribe oneself into these locally dominant painterly conventions. Hence, they engaged in the project of *pictorializing* the radically antipictorial legacy of dadaism. Rauschenberg's development of his own pictorial *bricolage* technique, applied in the first dye transfer drawings, such as *Cage* (1958) or *Mona Lisa* (1958), and unfolded as a method subsequently in the

monumental cycle of *Thirty-Four Drawings for Dante's Inferno* (1959–1960), had successfully fused the increasingly dominant presence of mass cultural imagery with high art purity at the same time as it fused the inherited idiom of Dada collage with the locally dominant painterly conventions of expressive gestural abstraction. Clearly, Rauschenberg had to appear to audiences of the 1950s as the enigmatic genius of a new age.

In 1962, Warhol had to consider whether he too, like his older peers, had to remain to some degree within the pictorial format and framework in order to avoid the failure of reception which some of Rauschenberg's own more radical *nonpictorial* works had encountered, or whether his efforts to depictorialize Johns and Rauschenberg could go as far as the more consequential work of artists such as Kaprow and Robert Watts or the European *nouveaux réalistes,* such as Arman. After 1958 to 1959, they had abandoned all gestures of compromise with New York School pictorialism in order to reconstitute radical readymade strategies, and—like their Fluxus colleagues—they would ultimately fail to generate interest among a New York audience avidly awaiting the next delivery of pictorial products that could be packaged in collections and exhibitions.[39]

By contrast, Warhol seems to have felt at first reluctant about an outright commitment to mechanical representation and readymade objects (as had already been evident in his paintings from the beginning of his career). As late as 1966, he considered it still necessary to defend his silkscreen technique against the commonly held suspicion that mechanical procedures and readymade objects were ultimately inartistic and fraudulent:

> In my art work, hand painting would take much too long and anyway that's not the age we're living in. Mechanical means are *today*. . . . Silkscreen work is as honest a method as any, including hand painting.[40]

Thus Warhol's solution, found in 1962, responded to all of these problems: his painting isolated, singularized, and centralized the representation in the manner of a Duchampian readymade (and in the manner of Johns's *Flags* and *Targets*) and extracted it thereby from the tiresome affiliation of collage aesthetics and the nagging neo-Dada accusation that had been leveled constantly against his older peers. Simultaneously, this strategy, with its increased emphasis on the mere photographic image and its crude and infinite reproducibility, furthered the erosion of the painterly legacy of the

New York School and eliminated all traces of the compromises that Rauschenberg still had had to make with that legacy.

Warhol's photographic silkscreens of single images, as much as the se-rial repetition of single images, eliminated the constant ambiguity between expressive gesture and mechanical mark from which Rauschenberg's work had drawn its tensions (and its relative conventionality). As a complement, the centralized readymade image eliminated the balances of relational composition that had functioned as the spatial matrix of Rauschenberg's relatively traditional pictorial and temporal narrativity. Yet, while seem-ingly a radical breakthrough, the photographic silkscreen procedure and the compositional strategies of singularization and serial repetition al-lowed Warhol to remain within the boundaries of the pictorial frame-work, a condition of compromise upon which he would always insist.

Warhol's adaptations of Rauschenberg's methods of mechanical im-age transfer (dye or silkscreen) subject these techniques to numerous crit-ical transformations. First of all, and most obviously, Warhol deprives his paintings of the infinite wealth of associative play and simultaneous mul-tiple references that Rauschenberg's traditional collage aesthetic had still offered to the viewer. By contrast, Warhol's image design (whether in its emblematic single unit structure or that of a multiple repetition of a single unit) extinguishes all poetic resources and prohibits the viewer's free asso-ciation of the pictorial elements, instead putting in its place the experience of a confrontational restriction. In a very literal manner, Warhol's singular-ized images become hermetic: secluded from all other images or stifled by their own repetition, they can no longer generate "meaning" and "narra-tion" in the manner of Rauschenberg's larger syntactic image assemblages. Paradoxically, this restriction and hermeticism of the semantically isolated image was at first generally experienced as the effect of absolute banality and boredom, or as an attitude of divine indifference and cynicism, or, worse yet, as a celebratory affirmation of consumer culture, when in fact it operated as the deliberate rejection of conventional demands upon the artistic object to provide plenitude, as the refusal to assume the socially de-sired functions of aesthetic legitimation. Warhol negates these expectations with the same asceticism that had articulated this negation in Duchamp's readymades.

This restriction to the single iconic image/repetition finds its proce-dural complement in Warhol's strategy of purging all remnants of painterli-ness from Rauschenberg's expressively compromised photographic images and to confront the viewer with a factual silkscreen reproduction of

the photographic image (as in the *Elvis* series, the *Disaster Series,* and the *Thirteen Most Wanted Men,* for example). In these paintings, the silkscreened photographic imprint remains the only trace of the pictorial manufacturing process. This technique assaults once again one of the central tenets of the modernist legacy: forcing those eager to rediscover medium-specific painterliness, individuality, and uniqueness of the painterly mark to detect it in the accidental slippages and flaws of a casually executed silkscreen process. In the following example, a fervent admirer of Greenberg's painterly norms, confronted with Warhol's work, makes a grotesque attempt to regain discursive control and tries to accommodate the blows that the modernist painterly aesthetic had received from Warhol's propositions:

> He [Warhol] can in fact now be seen as the sensitive master of a wide variety of surface incident, and a major effect of the experience of looking at his paintings is an unusually immediate awareness of the two-dimensional fact of their painted surfaces. . . . Both factors underline the reality of the paint itself as a deposit on the surface, quite apart from its interdependence with the image it supports.[41]

When paint is in fact added manually (as in many of the *Marilyn* and *Liz* portraits), it is applied in such a vapid manner, detached from gesture as expression as much as it is dislocated from contour as depiction (both features would become the hallmarks of Warhol's later portrait work), that it increases rather than contradicts the laconic mechanicity of the enterprise.

Extracting the photographic image from its painterly ambiguity not only foregrounded the mechanical nature of the reproduction but also emphasized the lapidary factual (rather than "artistic" or "poetical") information of the image, a quality that seems to have been much more surprising and scandalizing to viewers in the early 1960s than could now be reconstrued. Even a critic who in the early 1960s was unusually well acquainted with the Duchamp and Dada legacy seems to have been deceived by the apparent crudity of pop art's factual imagery:

> I find his images offensive; I am annoyed to have to see in a gallery what I'm forced to look at in the supermarket. I go to the gallery to get away from the supermarket, not to repeat the experience.[42]

Common Iconography

Warhol's critical dialogue with Rauschenberg's work finds its parallel in his critical revisions of the legacy of Johns. The key compositional devices that Warhol had derived from Johns's *Targets* and *Flags* and his *Alphabets* and *Numbers* were, on the one hand, the emblematic centrality of the singularized representation and, on the other, all-over serial grid composition. However, he insisted on counteracting the strangely neutral and universal character of Johns's icons with the explicit mass cultural iconicity of a different type of representation, images instantly recognizable as the *real* common denominators of collective perceptual experience. Johns's *Alphabets, Numbers, Targets,* and *Flags,* in spite of their commonality, suddenly looked arcane and hermetic compared with Warhol's imagery, like idiosyncratic objects remote from everyday experience. By responding to paintings such as Johns's *Flag on Orange Field* with his emblematic *Marilyn on Gold Ground,* Warhol made Johns's work seem to be safely entrenched in a protected zone of unchallenged and unquestionable high art hegemony. By contrast, his own new mass cultural iconography of consumption and the portraits of collective scopic prostitution looked suddenly more specific, more concretely present-day American than the American flag itself, perhaps in the way that Manet's *Olympia* had appeared more concretely Parisian to the French bourgeois in 1863 than Delacroix's *Liberté.* Warhol's drastically different painterly execution (the chintzy monochrome canvas surface, brushed with cheap gold paint and enhanced with a crudely superimposed, silkscreened photograph) drew Johns's paintings into an uncomfortable proximity to mass cultural glamour and crass vulgarity, where their high art status seemed to disintegrate right in front of our eyes (or would have, were it not for the irrepressible intimation that these paintings would soon be redeemed as the masterpieces that heralded an era of high art's own final industrialization).

Several questions remain open concerning the actual status and functions of the photographic imagery silkscreened by Warhol onto his canvases since 1962—questions that have been completely obliterated by the sensationalist effects of Warhol's iconography of spectacle and consumer culture. In fact, one could say that most of the Warhol (and pop) literature has merely reiterated these clichés of iconographic reading since the mid-1960s.

The first of these questions would concern the degree to which the sexualization of the commodity and the commodification of sexuality had

attracted artists already since the early to mid-1950s. British pop in partic-
ular had thrived on those juxtapositions of commodity imagery with (semi-
pornographic) movie star imagery and had fused the language of vulgar
gossip magazines with that of the idiocy of advertising copy. The most
notable examples are obviously Eduardo Paolozzi's *I Was a Rich Man's
Plaything* (1947) and Richard Hamilton's *Just What Is It that Makes
Today's Homes So Different, So Appealing?* (1956).[43] Once again, in Rausch-
enberg's work of the mid- to late 1950s we can find the germination of
that particular iconography and the methods specific for its display, meth-
ods that would soon contribute to Warhol's notorious iconographic iden-
tity. This would be prefigured not only in the numerous references to mass
cultural consumption in Rauschenberg's work of that time (e.g., *Coca-
Cola Plan* [1958]) but also in his frequent use of pin-up imagery, the seri-
ally repeated gossip column newsprint image of Gloria Vanderbilt in *Gloria*
(1956), or his use of an FBI wanted poster in *Hymnal* (1955).

But rather than searching for the iconographic sources of Warhol's
work, it seems more important to recognize the actual degree of postwar
consumer culture's pervasive presence. It appears to have dawned on the
artists of that decade that the imagery and objects of consumer culture had
irreversibly invaded and taken control of visual representation and public
experience. The following exhibition review from 1960 indicates that
awareness in the work of another artist working at the same time, but it
also delivers an astonishingly complete and detailed account of the images
that Warhol subsequently chose as the key figures of his iconographic pro-
gram:

> The show, called "Les Lions" (Boris Lurie, Images of Life, March
> Gallery, New York, May–June 1960), exciting disturbing nightmares
> of painting, montages cut out of magazines and newspapers, images
> of our life held together on canvases with paint . . . *atom bomb tests* and
> green Salem Cigarette ads . . . Home-Made Southern Style Instant
> Frozen Less Work For You *Tomato Juice.* Obsessively repeated
> throughout the paintings, girls . . . *Marilyn,* Brigitte, *Liz* and Jayne, the
> sweet and sticky narcotics that dull the pain. . . . *Life* magazine taken
> to its final ultimate absurd and frightening conclusion, pain and death
> given no more space and attention than pictures of Elsa Maxwell's lat-
> est party. And all of us spectators at our own death, hovering over it
> all in narcotized detachment, bored as gods with *The Bomb,* yawning

over The Election, coming to a stop at last only to linger over the
tender dream photos of *Marilyn*. (And they call it Life).[44]

How common the concern for these images actually was at the end of the
1950s and how plausible and necessary Warhol's iconographic choices
were becomes even more evident when looking once again at Kaprow's
prophetic essay "The Legacy of Jackson Pollock." In the last two para-
graphs, Kaprow almost literally predicts a number of Warhol's actual icono-
graphic types (or did Kaprow read these types off the same Rauschenberg
paintings that Warhol had internalized?):

> Not only will these bold creators show us as if for the first time the
> world we have always had about us, but ignored, but they will disclose
> entirely unheard of happenings and events found in garbage cans, *po-
> lice files,* hotel lobbies, seen in *store windows* and on the streets, and
> sensed in dreams and *horrible accidents*. . . . The young artist of today
> need no longer say "I am a painter" or "a poet" or "a dancer." All of life
> will be open to him. He will discover out of ordinary things the mean-
> ing of ordinariness. He will not try to make them extraordinary. Only
> their meaning will be stated. But out of nothing he will devise the ex-
> traordinary, and then maybe nothingness as well. People will be de-
> lighted, or horrified, critics will be confused or amused, but these, I am
> sure, will be the alchemies of the 1960s.[45]

In 1963, Warhol juxtaposed the most famous (and common) photo-
graphic images of glamorous stars with the most anonymous (and cruel)
images of everyday life: the photojournalist's coolly "detached" images of
car accidents (culled from an archive of photographs rejected even by the
daily papers for their unbearable horror of detail). In the following year,
Warhol constructed another, equally dialectic pair of photographic prac-
tices: the police mug shots from the FBI wanted posters, which made up
his *Thirteen Most Wanted Men,* were complemented by the pedestrian
look of the photobooth picture in his earliest series of self-portraits, which
thereafter ran parallel to the representations of fame and disaster.

Warhol thus groups together those photographic conventions that
implement the collective scopic compulsions: looking at the Other (in
endless envy at fame and fortune as much as in sadistic secrecy at catastro-
phe) and the perpetually vanishing Self (in futile tokens and substitutes).

He also articulated this dialectic of the photographic image as social representation with astonishing programmatic clarity:

> My death series was divided into two parts, the first one famous deaths and the second one people nobody ever heard of. . . . It's not that I feel sorry for them, it's just that people go by and it doesn't really matter to them that someone unknown was killed. . . . I still care about people but it would be much easier not to care, it's too hard to care.[46]

In a later interview in 1972, Warhol described the dialectic of Self and Other in his images of death in terms that would seem to confirm after all that an early knowledge of Brecht had left marks on the self-declared indifferent cynic:

> Actually you know it wasn't the idea of accidents and things like that, it's just something about, well it all started with buttons, I always wanted to know who invented buttons and then I thought of all the people who worked on the pyramids and then all those, I just always sort of wondered whatever happened to them why aren't they along, so I always thought, well it would be easier to do a painting of people who died in car crashes because sometimes you know, you never know who they are. . . . The people that you know they want to do things and they never do things and they disappear so quickly, and then they're killed or something like that you know, nobody knows about them so I thought well maybe I'll do a painting about a person which you don't know about or something like that.[47]

Early in 1964, Warhol used a found photobooth autoportrait as the poster to announce his second one-person exhibition in New York. His simultaneous attraction to both the anonymous mug shot and the photobooth portrait seems to have originated in the automatic photograph's achievement of destroying even the last remnants of specialized artistic vision. Paradoxically, while denying the validity of manual skill and technical expertise, the photobooth picture at the same time concretized—in whatever grotesque substitute—the historical need for the collective to be pictorially "re-presented" and made that instant representation universally accessible. In the automatic portraits of the photobooth, the "author" of the picture had in fact finally become a machine (Warhol's frequently stated desire).

The systematic invalidation of the hierarchies of representational func-
tions and techniques finds a corresponding statement in Warhol's announce-
ment that the hierarchy of subjects worthy to be represented will someday
be abolished, in his most famous dictum "In the future everybody will be
famous for fifteen minutes" (and it was only logical that Warhol sent the first
patrons who commissioned their portraits to the photobooth, as the ac-
counts of Ethel Scull and Holly Solomon testify).[48]

Although Warhol constructed images of Marilyn Monroe, Liz Taylor,
and Elvis Presley in the context of the tragicomical conditions of their
glamour, the paintings' lasting fascination does not derive from the con-
tinuing myth of these figures but from the fact that Warhol constructed
their image from the perspective of the tragic condition of those who con-
sume the stars' images in scopic cults:

> I made my earliest films using for several hours just one actor on the
> screen doing the same thing: eating or sleeping or smoking: I did this
> because people usually just go to the movies to see only the star, to eat
> him up, so here at last is a chance to look only at the star for as long as
> you like no matter what he does and to eat him up all you want to. It
> was also easier to make.[49]

This dialectic of spectacle culture and collective compulsion, revealing
in every image that glamour is only the stunning reflex of the scopic fixa-
tion of the collective, permeates Warhol's entire oeuvre. It culminates in
his films, which operate *in the movie theater* at each instant of their vastly
expanded viewing time as a deconstruction of the audience's participation
in that compulsion, while they operate *on the screen* as instances of col-
lective enablement, grotesque and deranged as the agents of that enable-
ment might appear in the uncensored and unstructured, decentralized and
rambling performances and monologues of individuals who have not
been trained in the professional delivery of the scopic goods (the "super-
stars" are, in this context, "superrealists" in Apollinaire's sense of the term).

Again, Warhol declared the intentions of his realist and real-time film
projects with unusual clarity:

> Well this way I can catch people being themselves instead of setting
> up a scene and shooting it and letting people act out parts that were
> written because it's better to act out naturally than act like someone

else because you really get a better picture of people being themselves instead of trying to act like they're themselves.[50]

The subversive humor of Warhol's reversal of representational hierarchies culminated (and was erased accordingly) in his execution of a commission he had received with several other pop artists from Philip Johnson in 1964 to decorate the facade of the New York State Pavilion at the New York World's Fair. It was for this occasion that the collection of diptychs of the *Thirteen Most Wanted Men* was originally conceived and produced, and it comes as no surprise that Warhol's *realistic* sabotage of a state government's desire to represent itself *officially* to the world was censored by then-Governor Rockefeller under the pretext of legalistic difficulties.[51]

When Warhol was notified of the decision that his paintings had to be removed, he instantly initiated a *comedic* reversal of high and low and suggested replacing the pictures of the thieves by a portrait of World's Fair director and Parks Commissioner Robert Moses (under whose legal authority the pavilion was placed)—a proposal that was in turn rejected by architect Philip Johnson. Warhol, with laconic detachment, settled for the most "obvious" solution, to cover the paintings with a coat of silver aluminum paint and let them speak of having been silenced into abstract monochromy.

Serial Breakdown and Display

Both the continuously foregrounded and repeated discussions of Warhol's pop iconography and even more so the work's subsequent pictorialization[52] have wrenched his work from Warhol's intricate reflection on the status and substance of the painterly object and from his efforts to incorporate contextual determinations into the definition and display of painting. Features that were aggressively antipictorial in their impulse and that had evidently been among Warhol's primary concerns in the early exhibitions have been obliterated in the process of acculturation. This would be true for the details of his notorious first exhibition at Irving Blum's Ferus Gallery in Los Angeles in 1962 and his second exhibition at that gallery a year later, but also for numerous details and proposals (most often rejected by curators and dealers) for some of the subsequent exhibitions from 1963 to 1966.

On the one hand, the installation of the thirty-two paintings at the Ferus Gallery was determined by the number of Campbell's soup varieties

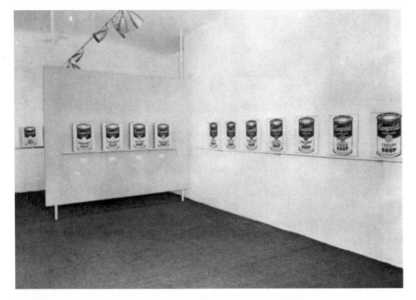

Installation view, *Campbell's Soup Cans,* Ferus Gallery, Los Angeles, 1962.

available at that time (Warhol actually used a list of Campbell products to mark off those flavors that had already been painted). Thus, in the first presentation of his work, the number of objects in an exhibition of high art was determined by the seemingly random and external factor of a product line and its variations (what latent system, one should ask on this occasion, normally determines the number of high art objects in an exhibition?). On the other hand, the paintings' *mode of display* was as crucial as was the principle of serial repetition and their commercial readymade iconography. Standing on small white shelves running along the perimeter of the gallery in the way that display shelves for consumer objects would normally function in a store, the paintings were still attached to the wall in the way that pictures would traditionally be installed in a gallery. And finally, the inevitable dimension of Warhol's own biographic detail is inserted into these paintings (and it is not important whether the remark is truthful or yet another *blague*) in his explanation of why he chose the Campbell's soup image: "I used to drink it. I used to have the same lunch every day, for twenty years, I guess, the same thing over and over again. Someone said my life has dominated me; I liked that idea."[53]

All three factors anchor the work in distinct framing systems that affect its reading beyond the merely iconographic concern of the "scandalous" pop imagery for which it became mostly known. What has been

misread as mere provocative banality is, in fact, the concrete specificity of the paintings' reified existence that ruins the traditional expectation for an aesthetic object's universal legibility from within, abolishing that claim with the same vehemence by which the subject's everyday experience is abolished between those systems of determination.

Yet at the same time this specificity imbues these paintings with an eerie concreteness and corporeality that, just a year earlier, had distinguished Piero Manzoni's *Merda d'artista,* but which Warhol transferred once again—as in his relationship to Johns's imagery—from the universality of corporeal experience onto the paradoxical level of mass cultural specificity (not bodily consumption but *product consumption* forms the material base of experience).

The absurdity of the individual aesthetic decision-making process becomes all the more obvious in the (aesthetic) variation of the same (the details of the labels' design and information). It is in this exact imitation of the minute variations and in the paintings' exact obedience to the officially available range of products that the series of Campbell's soup paintings goes far beyond what has been perceived as a mere iconographic scandal.

Inevitably, the *Campbell's Soup* series from 1962 and its installation recall a crucial moment of neo-avantgarde history when seriality, monochromy, and mode of display had broken down the unified and unique character of the easel painting—that is, Yves Klein's installation of eleven identical blue monochrome paintings in the Galleria Apollinaire in Milan in 1957 (repeated a few months later in Paris). Commenting on his exhibition, Klein said:

> All of these blue propositions, all alike in appearance, were recognized by the public as quite different from one another. The *amateur* passed from one to another as he liked and penetrated, in a state of instantaneous contemplation, into the worlds of the blue. . . . The most sensational observation was that of the "buyers." Each selected out of the . . . pictures the one that was his, and each paid the asking price. The prices were all different of course.[54]

Klein's installation and his commentary on it reveal both the degree of similarity of his attitude with that of Warhol's serial breakdown of modernist painting and the radical difference between the two propositions, which were separated by five years. While Klein's high cultural conservatism clearly intended to create a paradox, paralleling that of painting's si-

multaneous commodity existence and renewed metaphysical aspirations, Warhol's position of relentless affirmation canceled any such aspiration and liquidated the metaphysical dimension of the modernist legacy by rigorously subjecting each painting to the framing of identical product image and price.

That the serial breakdown of the painterly object and its repetition within the display were not just a topical idea for his first exhibition, but rather a crucial aesthetic strategy, became evident in 1968 when Mario Amaya asked Warhol to install a first European retrospective exhibition at the Institute of Contemporary Arts in London. Warhol suggested installing the series of thirty-two *Campbell's Soup* paintings throughout all of the spaces allocated for his show and making them the exclusive object of the retrospective. Amaya refused this proposal, just as the curators at the Whitney Museum in New York in 1970 refused Warhol's proposal to install only *Flower* paintings or *Cow Wallpaper* (glued backward onto the exhibition walls) as the exclusive objects of his retrospective exhibiton at that institution.[55]

For his second exhibition at the Ferus Gallery in Los Angeles in 1963 (the first one seems to have been at best a *succès de scandale* judging by the fact that none of the paintings, offered at $300 each, were sold), Warhol suggested once again a "monographic" exhibition: the recently produced series of single and multiple *Elvis* images, silkscreened on large monochrome silver surfaces. In fact, he apparently suggested that the "paintings" should be installed as a "continuous surround," and he shipped a single continuous roll of canvas with the silkscreened images to Los Angeles.[56]

As it had in his first installation in Los Angeles, this proposition threatened the boundaries of painting as an individually defined and complete pictorial unit. But now it subverted that status not only by serial repetition, but also by the sheer spatial expansion of that repetition—as though it were necessary to make it even more obvious. What had still been a real difficulty for Pollock—the final and crucial aesthetic decision of how and where to determine the size and the cut of the expanded field of painterly action and to avoid at all cost crossing over, as Harold Rosenberg put it, into the production of "apocalyptic wallpaper"—had now become a promise fulfilled by Warhol's deliberate transgression of those sacred limits that ultimately only confine the commodity.

It was therefore utterly logical that Warhol conceived an installation of *Wallpaper* for his supposedly final exhibition as a "painter" at the Leo Castelli Gallery in 1966—wallpaper imprinted with the by now notori-

ous (then utterly bland) image of a cow, that animal whose reputation it is to have a particular vapid and intent gaze. Juxtaposed with the *Cow Wall-paper* was Warhol's series of floating silver pillows which moved through the gallery, animated by air and the viewers' body movements. Rumor has it that Warhol referred to the *Cows* as "This is all of us," but the decor would not need that statement to make its point: all the elements of modernism's most radical and utopian promises—to evolve from pictorial plane through sculptural object to architectural space; to educate the viewer from an attachment to iconic representation to a liberatory mode of the self-reflexive, the indexical sign, and the tactile mode of participation; and to abandon the confines of the private viewing mode of the easel painting in favor of the space of simultaneous collective perception—all those utopian promises are annihilated in this installation, the farcical sacking of modernism and the gracefully atopian finale of the first ten years of Warhol's art.

Until 1966, Warhol's high art (as opposed to his films) thus oscillates constantly between an extreme challenge to the status and credibility of painting and a continuing deployment of strictly pictorial means and operation in the narrowly defined framework of pictorial conventions. Inevitably the question arises (and it has been asked again and again) whether or why Warhol never crossed the threshold into the actual conception (or rather, reconstitution) of the readymade.

Except for the occasional joke campaign like signing actual Campbell's soup cans, Warhol would never use the three-dimensional readymade object in its unaltered industrial existence, as a raw object of consumption. Yet at the same time, he would go further than any of his peers in the pop art context (not, however, as far as many of his peers in the Fluxus context, for example) in challenging the traditional assumptions about the uniqueness, authenticity, and authorship of the pictorial object, the very foundations upon which high modernist art had rested until Duchamp's definition of the readymade in 1917 and upon which the reconstruction of modernism had rested in the New York School context until the arrival of Warhol in 1962. Again and again, Warhol tantalized collectors, curators, and dealers by generating doubts about authenticity and authorship of his work and temporarily succeeded in actually destabilizing his own market. For example:

I made multiple color silkscreen painting—like my comic strip technique. Why don't you ask my assistant Gerard Malanga some questions? He did a lot of my paintings.[57]

Two answers, contradicting each other to some extent, seem to be necessary. The first is that Warhol emerged from a local tradition of artists who had distinguished themselves—as we have seen—by pictorializing the Dada legacy in their critical engagement with the heroic tradition of the New York School. And it was to the power and success of Johns and Rauschenberg that Warhol aspired in the early 1960s, not to the increasing marginalization that would obviously await all those other artistic practices that had actually abandoned picture production (such as the happening and Fluxus artists, for example). The critical distancing effect that Warhol wanted to insert between himself and his two major predecessors had to occur first of all within the means and the field of painting (rather than by abandoning painting abruptly in favor of "pure" readymades). Warhol would have to work through the last phases of the pictorialization begun by Rauschenberg and Johns, and go to the threshold of painting's abolition—a consequence that would soon emerge, mediated to a considerable degree by Warhol's work in the context of minimal and conceptual art.

The second answer is more speculative, and it assumes that Warhol was so deeply implicated in the pictorial medium, the relative autonomy of aesthetic conventions, and the relative stability of artistic categories inherent in that medium because he gradually had learned to accept the relative conventionality of his audience and of the institutional control and valorization of that medium. Therefore he decided not to transgress these conservative limitations inherent in painterly practice and refrained from acquiring (or reconstituting) the status of the unaltered readymade in any of his works until 1966.

Perhaps it was Warhol's skeptical and opportunistic positivism (to anticipate that all radical gestures within the framework of an institutionalized and industrialized high art production would inevitably and ultimately generate marketable artistic objects, would end up as mere "pictures" in a gallery, merely legitimizing the institutional and discursive conventions from which they emerged) that allowed him to avoid the mistakes inherent in Duchamp's radical proposition of the readymade. Duchamp had in fact been oblivious to both the false radicality of the readymade and the problem of its inevitable aestheticization. One of Duchamp's rare com-

ments about Warhol's work seems to indicate that he understood that implication, after all, when looking at Warhol's work: "What interests us is the *concept* that wants to put fifty Campbell's soup cans on a canvas."[58]

Reception

The recognition of Warhol's ingenuity and radicality obviously depended to a considerable degree on the historical limitations of his original audiences: in fact, his strategies appeared to be extraordinary scandals in the face of the New York School climate of the late 1950s and that generation's general indifference, most often fused with aggressive contempt—as exemplified by Greenberg—toward the Dada and Duchamp legacy. By contrast, Warhol's interventions into the aesthetic of the early 1960s would seem fully plausible and necessary to a viewer aware of the implications of the Dada legacy, in terms of that movement's continuous emphasis and reflection of the inescapable symbiotic ties between aesthetics and commodity aesthetics.

Warhol's "scandalous" assaults on the status and the "substance" of pictorial representation were motivated by the rapidly dwindling options of credible artistic production, a fact that had become more and more apparent as the conventions of modernism and avant-garde practice had finally been rediscovered, but even more so by the increasing pressure and destruction that the accelerated development of the culture industry exerted now on the traditionally exempt spaces of marginal artistic deviance. Iconography, *blague* gesture, production procedure, and modes of distribution and display in Warhol's work mimetically internalize and repeat the violence of these changing conditions and dissolve as artistic objects along with the rapidly disappearing reality of any option to sustain deviance and dissent within a rigorously organized system of immediate and continuous commercial and ideological recuperation.

But of course, as had been the case with Duchamp and Dada before, these practices celebrated the destruction of the author and the aura of aesthetic substance and artistic skill with the same vehemence as they recognized in that destruction an irrecuperable loss. Yet, within this moment of absolute loss, Warhol uncovered the historical opportunity to redefine (aesthetic) experience.

To understand the *relative* radicality of Warhol's gesture, with regard both to the historical legacies of Duchamp and Dada as well as the immediately preceding and contemporary artistic environment of the Cage

legacy—in particular, American Fluxus and happenings and European *nouveau réalisme*—does not minimize his achievements at all.

Quite to the contrary, the ambition to make Warhol an all-American pop artist belittles his historical scope as much as it underrates the universal presence of those conditions of experience determining his work. Already in 1963 Henry Geldzahler described the reasons for this universality with the breathtaking frankness of the imperialist victor:

> After the heroic years of Abstract Expressionism a younger generation of artists is working in a new American regionalism, but this time because of the mass media, the regionalism is nationwide, and even exportable to Europe, for we have carefully prepared and reconstructed Europe in our own image since 1945 so that two kinds of American imagery, Kline, Pollock, de Kooning on the one hand, and the Pop artists on the other, are becoming comprehensible abroad.[59]

In European countries of advanced capitalist culture, Warhol's work was adamantly embraced (at first in West Germany, but subsequently also in France and Italy) as a kind of high culture version of the preceding and subsequent low culture cults of all things American. It seems that these cult forms celebrated in masochistic folly the subjection to massive destruction that the commodity production of late capitalism would hold in store for the postwar European countries, and inevitably Warhol's work would acquire the suggestive nature of prophetic foresight.

Therefore it cannot surprise us that the key collectors of Warhol's work in Europe, at first the West German scalp cosmetics industrialist Ströher, followed by the chocolate tycoon Ludwig, and most recently by the Saatchi admen in London, recognize *their* identity as well in Warhol's work and perceive that identity as culturally legitimized. While they are instrumental in inflicting those conditions of enforced consumption that Warhol's work seems to passively condone as "our universal nature," it would still seem that they are mistaken in reading his postures and his artifacts as an affirmative celebration of theirs.

Warhol has unified within his constructs the views of both the victors and victims of the late twentieth century: the entrepreneurial world view, its ruthless diffidence and strategically calculated air of detachment that allows it to continue its operations without ever being challenged in terms of its sociopolitical or ecological responsibility; and the phlegmatic vision of the victims of that world view, the consumers, the "all-round reduced

personality," who can celebrate in Warhol's work their proper status of having been erased as subjects. Reduced to being constituted in the eternally repetitive gestures of alienated production and alienated consumption, they lack the slightest opening toward a dimension of critical resistance.

Notes

1. Gretchen Berg, "Andy: My True Story," *Los Angeles Free Press,* March 17, 1967, n.p. (reprinted from *East Village Other*).

2. Gregory McDonald, "Built in Obsolescence: Art by Andy Warhol," *Boston Sunday Globe,* October 23, 1966, p. 17.

3. See *Andy Warhol's Index Book* (New York: Random House, 1967). The logo appears in the midst of photographs of the factory displaying Mott's, Heinz's, and Campbell's products as an exceptional and lonely variation on the eternal repetition of the same logotypes and brands in Warhol's art of the time. Chanel No. 5 and Mobil each become the subject of one plate in Warhol's late, nostalgic recollection of advertisement styles and history in his portfolio *Ads;* see Frayda Feldman and Jörg Schellmann, eds., *Andy Warhol Prints (A Catalogue raisonné)* (New York: Ronald Feldman Fine Arts, Edition Schellmann, and Abbeville Press, 1985), pp. 106–107.

4. Patrick S. Smith has suggested that the script is actually the handwriting of Andy Warhol's mother and that Warhol even had a stamp made to be able to replicate his mother's naive handwriting signature at all times. See Patrick S. Smith, *Andy Warhol's Art and Films* (Ann Arbor: UMI Research Press, 1986), p. 32. Punning on his phone number, Murray Hill 3-0555 at 242 Lexington Avenue, seems to have been a consistent joke in Warhol's auto-promotional advertisements: thus, in 1954, he published an ad in *Ergo,* a cooperative brochure by a group of freelance commercial artists, listing his phone exchange as "Mury heel." See Andreas Brown, *Andy Warhol: His Early Works 1947–1959* (New York: Gotham Book Mart, 1971), p. 14.

5. Rosalind H. Williams, *Dream Worlds: Mass Consumption in Late Nineteenth Century France* (Berkeley: University of California Press, 1982), p. 67, quoted in Simon Frith and Howard Horne, *Art into Pop* (New York and London: Methuen, 1987), p. 12.

6. This role change was of course not as abrupt as that. It appears that Warhol continued to work as a commercial designer at least as late as 1962.

7. Andy Warhol, "Happy Butterfly Day," published by *Vanity Fair,* circa 1955. The Archives of Andy Warhol, New York.

8. See Trevor Fairbrother, "Warhol Meets Sargent at Whitney," *Arts Magazine* 61 (February 1987): 64–71.

9. "I adore America and these are some comments on it. My image is a statement of the symbols of the harsh, impersonal products and brash materialistic objects on which America is built today. It is a projection of everything that can be bought and sold, the practical but impermanent symbols that sustain us." Andy Warhol, "Artist's Comment," special issue "New Talent USA," *Art in America* 50, no. 1 (1962): 42.

This statement appeared underneath a reproduction of Andy Warhol's painting *Storm Door* (1960), which was surprisingly included in the "prints and drawings" section of this "New Talent USA" issue, curated by Zachary Scott, an actor and collector of contemporary prints. The size is indicated as 36 × 34 inches (as opposed to the painting's actual size

of 46 × 42 1/8 inches), which makes one wonder whether the curator's desire to include Warhol in this section required some tampering with both medium and size to make the work suitable for this category, since both its iconography and pictorial execution most likely would have made its inclusion in the painting section impossible.

10. Perry Anderson, "Modernity and Revolution," *New Left Review* 144 (March–April 1984): 106.

11. Allan Kaprow, "Should the Artist Become a Man of the World?" *Art News* 63, no. 6 (October 1964): 34.

12. Nan Rosenthal discussed the details of that curriculum at Carnegie Tech and its profound impact on Warhol's education in a paper delivered at the Andy Warhol Symposium, organized by the Dia Art Foundation in New York in the spring of 1988. See Gary Garrels, ed., *The Work of Andy Warhol* (Seattle: Bay Press, 1989). Previously, Patrick S. Smith had argued for a comparison between Warhol's mechanization of fine art production procedures and the ideas taught by Moholy-Nagy at the Chicago Bauhaus (The Institute of Design) and in his writings, in particular *The New Vision*, 3d rev. ed. (New York: Wittenborn and Company, 1946). Apparently this book was well known to Warhol and extensively discussed by him and his friends in the late 1940s. See Smith, *Andy Warhol's Art and Films,* pp. 110–112 and nn. 191–205.

13. Andy Warhol, "Underground Films: Art or Naughty Movies," interview by Douglas Arango, *Movie TV Secrets* (June 1966).

14. Andy Warhol, "Nothing to Lose," interview by Gretchen Berg, *Cahiers du Cinéma,* English ed. (May 1967): 39–43. In 1971, already with an ironic distance, he would still say: "If I remember correctly, I felt that if everyone couldn't afford a painting the printed poster would be available." See Andy Warhol, "A Conversation with Andy Warhol," interview by Gerard Malanga, *Print Collector's Newsletter* 1, no. 6 (January/February 1971): 125–127. The same argument for the radically egalitarian and anti-elitist conceptions motivating pop art is also made by Claes Oldenburg, for example: "I think it would be great if you had an art that could appeal to everybody." See Bruce Glaser, "Oldenburg, Lichtenstein, Warhol: A Discussion," *Artforum* 4, no. 6 (February 1966): 20–24. It is all the more astonishing that an early critical opponent (and subsequent convert) of pop art refused to acknowledge the actual egalitarian potential of pop art from the beginning (and, in retrospect, it turns out that the skepticism was wholly justified). In her review of Lawrence Alloway's 1963 exhibition "Six Painters and the Object" at the Guggenheim Museum, Barbara Rose would write: "In the past, when an artist like Courbet or van Gogh appropriated material from popular culture, it was with the intent of reaching a larger public—in fact of producing a kind of elevated popular art. *Pop art in America had no such intention; it was made for the same exclusive and limited public as abstract art*" (italics mine). Barbara Rose, "Pop Art at the Guggenheim," *Art International* 2, no. 1 (1963): 20.

15. Walter P. Paepcke, "Art in Industry," in Container Corporation of America, *Modern Art in Advertising* (Chicago: P. Theobald, 1946), n.p.

16. Andy Warhol, *The Philosophy of Andy Warhol (from A to B and Back Again)* (New York: Harcourt Brace Jovanovich, 1975), p. 92.

17. See "Boxing Match," *Time* (May 15, 1964): 86.

18. Warhol was notorious for consciously lifting or employing other people's "ideas," and he was quite candid (and coy) about this supposed absence of "originality": "I always get my ideas from people. Sometimes I change the idea to suit a certain project I'm working on at the time. Sometimes I don't change the idea. Or, sometimes I don't use the idea right away,

but may remember it and use it for something later on. I love ideas." Warhol, interview by Malanga, pp. 125–127.

19. Gene R. Swenson, "What Is Pop Art? Interviews with Eight Painters (Part I)," *Art News* 62 (November 1963): 24–27, 60–63.

20. Martha Jackson to Andy Warhol, letter, July 20, 1962. Andy Warhol Archive, New York.

21. A similar stylistic hesitation can be found in the early work of Roy Lichtenstein, who in the late 1950s was going through the transition from being an abstract expressionist painter to a painter deploying readymade imagery and readymade (commercial) techniques of pictorial execution. Andy Warhol was surprised to discover that he had not been the only one to use the iconography of comic strips in his newly defined work. What was worse for Warhol was that Leo Castelli at that time believed that his gallery should show only one artist using this type of imagery. Lichtenstein has recorded his memory of that surprising encounter: "I saw Andy's work at Leo Castelli's about the same time I brought mine in, about the spring of 1961. . . . Of course, I was amazed to see Andy's work because he was doing cartoons of Nancy and Dick Tracy and they were very similar to mine." Bruce Glaser, "Oldenburg, Lichtenstein, Warhol: A Discussion," *Artforum* 4, no. 6 (1966): 20–24.

22. Emile de Antonio's original commentary has been reported in two versions: "One of these is crap. The other is remarkable—it's our society, it's who we are, it's absolutely beautiful and naked, and you ought to destroy the first and show the second." See Jesse Kornbluth, "Andy," *New York* (March 9, 1987): 42. The other version confirms the assumption that there was a moment of real hesitation in Warhol's early work. It reads: "One day he put up two huge paintings of Coke bottles. Two different ones. One was, I could say, an early Pop Art piece of major importance. It was just a big black-and-white Coke bottle. The other was the same thing except it was surrounded by Abstract Expressionist hatches and crosses. And I said to Andy, 'Why did you do two of these? One of them is so clearly your own. And the second is just kind of ridiculous because it's not anything. It's part Abstract Expressionism and part whatever you're doing.' And the first one was one that was any good. The other thing—God only knows what it is. And, I think that helped Andy make up his mind as to—you know: that was almost the birth of Pop. Andy did it." See Smith, *Andy Warhol's Art and Films*, p. 97. Warhol followed the advice only partially: he exhibited the "cold" version at his first New York exhibition at the Stable Gallery in 1962, but he did not destroy the other version. It is reproduced in Rainer Crone's early catalogue raisonné as No. 3 on page 83. See Rainer Crone, *Andy Warhol* (New York: Praeger, 1970).

23. For example, in Carter Ratcliff, *Andy Warhol* (New York: Abbeville Press, 1983), p. 17: "Though Warhol has never changed his personal style, he did abandon commercial art as decisively as he possibly could. The line between his first and second careers is astoundingly sharp."

24. Allan Kaprow, "The Legacy of Jackson Pollock," *Art News* 57, no. 6 (October 1958): 56.

25. For an early example of this argument emphasizing the desire for stylistic alteration as the main motivation in the development of pop art, see Robert Rosenblum, "Pop and Non-Pop: An Essay in Distinction," *Art and Literature* 5 (Summer 1965): 80–93. For the same argument in the context of an early discussion of Warhol's work, see Alan Solomon's introduction to the catalogue of the Andy Warhol exhibition at the Institute of Contemporary Art in Boston, 1966: "In a broader sense, I suppose the prevalence of cool passivity can be explained as part of the reaction to abstract expressionism, since the present attitude is the polar opposite of the action painting idea of kinetic self-expression. (This has a great deal to do with Warhol's attitudes toward style and performance. . . .)" For a more recent ex-

ample proving the persistence of this simplistic argument of stylistic innovation, see Ratcliff, *Andy Warhol*, p. 7.

26. Kaprow, "The Legacy of Jackson Pollock," p. 56.

27. See Michael Crichton, *Jasper Johns* (New York: Abrams, 1977), p. 30. Andrew Forge describes this type of new collaborative aesthetic in the context of Rauschenberg's work in terms that equally deemphasize visuality as the object's exclusive or even primary level of interaction. For example: "The idea of collaboration with others has preoccupied him endlessly, both through the medium of his own work and in an open situation in which no single person dominates. In *Black Market* (a 1961 combine painting) he invited the onlooker to exchange small objects with the combine and to leave messages." Andrew Forge, *Rauschenberg* (New York: Abrams, 1972), p. 15.

28. According to Eleanor Ward, one *Dance Diagram (Tango)* was already included in Warhol's first New York one-person exhibition at her Stable Gallery in 1962 and installed on the floor. See Eleanor Ward's recollection of that exhibition, "Other Scenes," in John Wilcock, ed., *The Autobiography and Sex Life of Andy Warhol* (New York: Other Scenes, Inc., 1971). Subsequently, *Dance Diagram (Fox Trot)* was installed in a horizontal position in Sidney Janis's important exhibition "The New Realism" in December 1962 and again in Warhol's first "retrospective" exhibition in 1965 at the Institute for Contemporary Art in Philadelphia. It was of course a particularly Warholian irony, even if unintended, that the attendance at the exhibition's opening was so massive that all paintings (not just those on the floor) had to be removed from the exhibition for the duration of the "preview."

29. Harold Rosenberg, "The American Action Painters," *Art News* 51, no. 5 (September 1952).

30. Quoted in Annabelle Melzer, *Dada and Surrealist Performance* (Ann Arbor: UMI Research Press, 1980), p. 17.

31. Such a moment of the "breakdown" of the strategy of the monochrome (and perhaps an indication of the generally increasing doubts about the paradigm's continued validity) is poignantly described by Michael Fried in a review of an exhibition of Barnett Newman's work in 1962 which he published—as historical chance had it—side by side with his review of Andy Warhol's first New York exhibition:

> From the start—which I take to be the late forties—his art was conceived in terms of its absolute essentials, flat colour and a rectilinearity derived from the shape of the canvas, and the earliest paintings on view have a simplicity which is pretty near irreducible. . . . When the equilibrium is not in itself so intrinsically compelling and the handling of the paint is kept adamant the result is that the painting tends not to hold the eye: the spectator's gaze keeps bouncing off, no matter how hard he tries to keep it fixed on the painting. (I'm thinking now most of all of the vertical painting divided into unequal halves of ochre yellow and white dated 1962 in the current show, in which the colours themselves, unlike the warm fields of blue that are perhaps Newman's most effective element—have no inherent depth to them and end up erecting *a kind of hand-ball court wall for the eye.*)

Michael Fried, "New York Letter," *Art International* 6, no. 10 (December 1962): 57. That the monochrome aspects in the work of Barnett Newman were subject to a more general reflection in the early 1960s would also be indicated by Jim Dine's rather unsuccessfully parodic *Big Black Zipper* (1962) (Ileana Sonnabend Collection, Baltimore Museum of Art).

32. Allan Kaprow, "Should the Artist Become a Man of the World?" *Art News* 63, no. 6 (October 1964): 34.

33. Alan Solomon made the connection between the monochrome paintings and the floating pillows as early as 1966, even though in the rather foggy and evasive language of the enthused critic: "When Warhol made the *Clouds* which are floating plastic sculpture, he called them paintings, because he thought of filling them with helium and sending them out of the window, never to return. 'That would be the end of painting,' he said, as serious as not. (He also likes the idea of plain surfaces as ultimate art. Many of his paintings have matching bare panels which he feels increase their beauty appreciably.)" Alan Solomon, *Andy Warhol* (Boston: Institute of Contemporary Art, 1966). A year later, Warhol would describe the project in more concise terms: "I didn't want to paint anymore so I thought that the way to finish off painting for me would be to have a painting that floats, so I invented the floating silver rectangles that you fill up with helium and let out of your windows." Warhol, interview by Berg, p. 43.

In his later recollections entitled *POPism,* Warhol remembers that it was on the occasion of his exhibition at the Ileana Sonnabend Gallery in Paris, where he had installed the *Flower* paintings on the recently designed *Cow* wallpaper, that he decided to publicly declare the end of painting (or at least his involvement with it): "I was having so much fun in Paris that I decided it was the place to make the announcement I'd been thinking about making for months: I was going to retire from painting. Art just wasn't fun for me anymore." Andy Warhol and Pat Hackett, *POPism: The Warhol '60s* (New York: Harcourt Brace Jovanovich, 1980), p. 113.

It seems noteworthy, once again, that while Warhol considered it appropriate to emphasize ironically that "Paris was the place to make the announcement," some American critics have not been able to acknowledge that Warhol's declaration of "silence" inscribed him in a Rimbaud/Duchamp tradition of self-imposed refusal of artistic production. Thus Carter Ratcliff, for example, in his monograph identifies it as a "Garboesque" decision (Ratcliff, *Andy Warhol,* p. 7).

Ten years after his first declaration, Warhol (after having taken up painting again) still struggles with the problem (or the pose?): "I get so tired of painting. I've been trying to give it up all the time, if we could just make a living out of movies or the newspaper business, or something. It's so boring, painting the same picture over and over." Andy Warhol, interview by Glenn O'Brien, *High Times* (August 1977): 21.

34. Andy Warhol, "Modern 'Myths': An Interview with Andy Warhol," interview by Barry Blinderman, *Arts Magazine* 56, no. 2 (October 1981).

35. One could refer to the complexity of Warhol's critical reflection on *all* of the implications of modernist pictorial conventions and his actual decision to foreground these in the rather unusual display propositions in order to point out—if it were not already so obvious—how tame and conservative by comparison the so-called neo-geo and the neoconceptualist artists are in their simple-minded and opportunistic "painting and sculpture" mentality, disguised behind the facade of postmodernist pretenses and the hyping of theory.

36. Andy Warhol, "Superpop or a Night at the Factory," interview by Roger Vaughan, *New York Herald Tribune,* August 8, 1965.

37. One of Rauschenberg's blueprints was shown in the exhibition "Abstraction in Photography" at the Museum of Modern Art, New York, in May–July 1951 and was listed in the catalogue as *Blueprint: Photogram for Mural Decoration.* An article on Rauschenberg's photograms/blueprints was published in *Life,* April 19, 1951, entitled "Speaking of Pic-

tures." See Lawrence Alloway, "Rauschenberg's Development," in *Robert Rauschenberg* (Washington: National Collection of Fine Arts, Smithsonian Institution, 1977), p. 16 and p. 63.

38. The complex relationships at the beginning of Warhol's career as an "artist" between him and his slightly older peer Robert Rauschenberg (b. 1925) and his slightly younger but considerably more established peer Jasper Johns (b. 1930) remain somewhat elusive. Apparently Warhol's ambition to be recognized by these two artists was frustrated on several occasions, for two reasons, as Emile de Antonio has reported. First, Warhol's background as a *real* commercial artist disqualified him in the eyes of these artists who, if they had to make money, would decorate Bonwit Teller windows under a pseudonym, and second, it seems they sensed that Warhol's work was outflanking their own. In *POPism,* Warhol remembers the commentaries on that relationship from a conversation with his friend de Antonio: "You're too swish, and that upsets them. . . . You are a commercial artist, which really bugs them because when they do commercial art–windows and other jobs I find them—they do it just 'to survive.' They won't even use their real names. Whereas you've won prizes! You're famous for it" (pp. 11–12). Or as de Antonio remembers: "Rauschenberg and Jasper Johns didn't want to meet Andy at the beginning. . . . Andy was too effeminate for Bob and Jap. . . . I think his openly commercial work made them nervous. . . . They also, I think, were suspicious of what Andy was doing—his serious work—because it had obvious debts to both of them in a funny way." Emile de Antonio, interview by Patrick S. Smith, in Smith, *Andy Warhol,* pp. 294–295.

Leo Castelli remembers Andy Warhol visiting his gallery in 1958–1959 as "a great admirer of Rauschenberg and Jasper Johns and he even bought a drawing, a good one, a light bulb drawing of Jasper Johns." Leo Castelli, interview by David Bailey, in *Andy Warhol: Transcript of David Bailey's ATV Documentary* (London, 1972, n.p.), and Leo Castelli, "Andy Warhol: Quelques grands témoins: Sidney Janis, Leo Castelli, Robert Rosenblum, Clement Greenberg," interview by Ann Hindry, *Artstudio* 8 (1988): 115. Recognition by his peers seems to have occurred after all sometime in the mid-1960s, when both Johns and Rauschenberg became owners of one or more paintings by Warhol.

39. For example, both Allan Kaprow and Robert Watts were already absent from Sidney Janis's crucial exhibition "The New Realism" in 1962; their absence is explained in Sidney Janis's preface by "limitation of space." See Sidney Janis, "On the Theme of the Exhibition," *The New Realism* (New York: Sidney Janis Gallery, 1962).

40. Warhol, interview by Arango, n. 7.

41. Richard Morphet, "Andy Warhol," in *Andy Warhol* (London: Tate Gallery, 1971), p. 6. Another, equally desperate attempt to detach Warhol's iconography from the reading of his work in order to force it back into the discursive strictures of (Greenbergian) modernism was made early on by Donald Judd:

> The subject matter is a cause for both blame and excessive praise. Actually it is not very interesting to think about the reasons, since it is easy to imagine Warhol's paintings without such subject matter, simply as "overall" paintings of repeated elements. The novelty and the absurdity of the repeated images of Marilyn Monroe, Troy Donahue and Coca-Cola bottles is not great. . . . The gist of this is that Warhol's work is able but general. It certainly has possibilities, but it is so far not exceptional. It should be considered as it is, as should anyone's, and not be harmed or aided by being part of a supposed movement, "pop," "O.K.," neo-Dada or New Realist or whatever it is.

Donald Judd, "Andy Warhol," *Arts Magazine* (January 1963), reprinted in Judd, *Complete Writings 1959–1975* (Halifax and New York: New York University Press, 1975), p. 70.

42. Barbara Rose, "Pop Art at the Guggenheim," *Art International* 8, no. 5 (May 25, 1963): 20–22. It is not quite clear from the text whether this statement relates to Warhol or Lichtenstein, but in any case it indicates the intense shock of factuality that the new mass cultural iconography of pop art provided even to well-prepared eyes.

In his 1962 exhibition catalogue *The New Realism,* Sidney Janis identifies the artists in his exhibition as "Factualists," and distinguishes them from Rauschenberg and others who are "less factual than they are poetic or expressionist."

In his review of Warhol's movie *The Chelsea Girls,* Andrew Sarris would recognize this "factualist" quality in Warhol's work and go as far as comparing Warhol's film to one of the key works of documentary film: "*The Chelsea Girls* is actually closer to *Nanook of the North* than to *The Knack.* It is as documentary that the *Chelsea Girls* achieves its greatest distinctions." Andrew Sarris, "The Sub–New York Sensibility," *Cahiers du Cinéma* (May 1967): 43.

43. For a recent discussion of the history of British pop art, see Brian Wallis, ed., *This Is Tomorrow Today: The Independent Group and British Pop Art* (Long Island City, N.Y.: Institute for Art and Urban Resources, 1987).

44. Bill Manville, *Village Voice,* June 16, 1960.

45. Kaprow, "The Legacy of Jackson Pollock," p. 57.

46. Andy Warhol as quoted by Peter Gidal, *Andy Warhol: Films and Paintings* (London: Studio Vista; New York: Dutton Picturebook, 1971), p. 38.

47. Andy Warhol, interview by Bailey. The statement about the anonymous people who built the pyramids is, of course, an (unconscious) quotation from Bertolt Brecht's famous poem "Das Manifest." An early argument for a profound influence of Brecht's work on Warhol had been made by Rainer Crone in his monograph *Andy Warhol,* partially on the grounds of speculation and the evidence of one reference by Warhol to Brecht in his early interview with Gene Swenson. More recently, Patrick S. Smith has anxiously attempted to detach Warhol from this political affiliation on the grounds of totally unconvincing "memories" by early acquaintances of Warhol whom Smith had interviewed. See Bert Greene, "Theatre 12 and Broadway," interview by Patrick S. Smith, in *Warhol: Conversations about the Artist* (Ann Arbor: UMI Research Press, 1988), p. 41, as well as Smith's dissertation, *Andy Warhol's Art and Films,* p. 78 ff.

48. It should be remembered that the identification of the artist with the criminal is one of the topoi of modernity since Baudelaire and that the identification of the two roles would have been familiar to Warhol from his readings of Jean Genet, to whom he referred on several occasions. Of course, as has been pointed out by several authors before, the conflation of the artist's portrait with the police mug shot goes once again back to Duchamp, who had superimposed the image of the artist over that of the "Most Wanted Man" in his assisted readymade *Wanted/$2,000 Reward* (1923). Duchamp had included a replica of this readymade in his *Boîte en Valise* in 1941 and had also used the image quite appropriately for the poster of his first American retrospective at the Pasadena Art Museum in 1963. Warhol attended the opening of this exhibition, and it is quite likely that the poster initiated Warhol's series of *Thirteen Most Wanted Men* in 1964 (previously they have erroneously been dated 1963). Furthermore, as Patrick S. Smith has pointed out, Rauschenberg had used an FBI wanted poster in *Hymnal* (1955).

The use of the photobooth strip once again also leads directly into the work of Jasper Johns, in particular the image of an unidentified man in *Flag above White with Collage* (1955), but also the self-portraits by Johns used in *Souvenir I* and *II* (1964).

For a cover commission for *Time* magazine in 1965, Warhol used a whole series of photobooth pictures, and there are still dozens of photobooth strips of Warhol and his friends in the Warhol archives (as there are dozens of photobooth strips in most everybody's archive of typical sixties' memorabilia).

49. Warhol, interview by Berg, p. 40. In this regard, Michael Fried's brilliant review of Andy Warhol's first New York exhibition has been proven wrong, since it is not the parasitic dependence of Warhol's images on mass cultural myths but the work's participation in the subject's (continuing) mass cultural experience that animates it:

> An art like Warhol's is necessarily parasitic upon the myths of its time, and indirectly therefore upon the machinery of fame and publicity that market[s] these myths; and it is not at all unlikely that these myths that move us will be unintelligible (or at best starkly dated) to generations that follow. This is said not to denigrate Warhol's work but to characterize it and the risks it runs—and, I admit, to register an advance protest against the advent of a generation that will not be as moved by Warhol's beautiful, vulgar, heart-breaking icons of Marilyn Monroe as I am.

Michael Fried, "New York Letter," *Art International* 6, no. 10 (December 1962): 57.

50. Andy Warhol, "Notes on My Epic," interview with unidentified interviewer, in *Andy Warhol's Index Book*.

51. The argument was that some of the criminals depicted in the *Thirteen Most Wanted Men* in the meantime had already received fair trial and that their images from the search warrant could therefore no longer be publicly displayed. The anecdote inevitably brings to mind the famous erasure of another important New York mural painting by an older member of the Rockefeller family. Apparently Philip Johnson's decision to censor the second proposal by Warhol as well caused a considerable strain on his relationship with Warhol: "And then he proposed to show a portrait of Robert Moses instead of the *Thirteen Most Wanted Men*? Yes, that's right . . . since he was the boss of the World Fair, but I prohibited that. . . . Andy and I had a quarrel at that time, even though he is one of my favorite artists." Crone, *Andy Warhol,* p. 30.

52. The first step in this direction was, as usual, to convince Warhol that each work had to be signed individually by him (no longer by his mother, for example, as in his days as a commercial artist), in spite of the fact that he had originally considered it to be crucial to *abstain* from signing his work: "People just won't buy things that are unsigned. . . . It's so silly. I really don't believe in signing my work. Anyone could do the things that I am doing and I don't feel they should be signed." Warhol, interview by Roger Vaughan, p. 7.

53. Warhol, interview by Swenson.

54. I am not suggesting that Warhol necessarily knew about Klein's exhibition, quite the opposite: the parallels would indicate once again, as was the case with the reference to the Manzoni work, to what extent these gestures originated in an inescapable condition.

However, one should know that Yves Klein had an exhibition at the Leo Castelli Gallery in New York in April 1961 and in May/June of the same year at the Dwan Gallery in Los Angeles, both entitled "Yves le monochrome." Certainly Warhol was interested in Klein's work at a later point in his life when he acquired two paintings by Klein in the mid-1970s. For an extensive discussion of Klein's project and his own commentaries on this exhibition,

see Nan Rosenthal's essay "Assisted Levitation: The Art of Yves Klein," in *Yves Klein* (Houston and New York: Menil Foundation, 1982), pp. 91–135.

55. For an excellent and detailed discussion of Warhol's constant reflection on the framing conditions of institutional conventions and exhibition formats, see Charles F. Stuckey, "Andy Warhol's Painted Faces," *Art in America* (May 1980): 102–111. My remarks are indebted to this essay in many ways as well as to a presentation by Charles F. Stuckey at the Andy Warhol Symposium at the Dia Art Foundation in New York in the spring of 1988.

56. See John Coplans, "Andy Warhol and Elvis Presley," *Studio International* (February 1971): 49–56. There are slightly conflicting opinions about who made the decision to stretch the canvas on stretchers after all: Coplans suggests that it was Warhol who sent the stretchers prefabricated to size from New York (which doesn't seem to make a lot of sense); Wolfgang Siano in his essay "Die Kunst Andy Warhol's im Verhältnis zur Oeffentlichkeit," in Erika Billeter, ed., *Andy Warhol* (Bern, 1971), suggests (without giving the source of his information) that it was originally Warhol's intention to install the canvas roll continuously along the perimeter of the gallery walls and that it was the decision of Irving Blum to divide the canvas roll into segments and stretch them as paintings. More recently, Gerard Malanga has voiced doubts that a roll of that size could have been screened continuously in the space available at the Factory at that time.

57. See Nat Finkelstein, "Inside Andy Warhol," *Cavalier Magazine* (September 1966): 88. As late as 1971, Warhol would still derange the curator's and collector's insistence on the stability of artistic categories (and thereby obviously weaken the reliability of his work in terms of institutional valorization and investment value): "I suppose you could call the paintings prints, but the material used for the paintings was canvas. . . . Anyone can do them." See Malanga, interview by Smith, *Print Collector's Newsletter,* p. 127.

Even after he resumed painting in 1968, Warhol disseminated rumors that the new paintings were in fact executed by his long-time friend Brigid Polk. As she stated in *Time,* October 17, 1969: "Andy? I've been doing it all for the last year and a half, two years. Andy doesn't do art anymore. He's bored with it. I did all his new soup cans." By contrast, since the mid-1970s, quite appropriate for both the general situation of a return to traditional forms of easel painting and his own complacent opportunism, he would recant those rumors, not, however, without turning the screw once again. Answering the question whether collectors had actually called him and tried to return their paintings after Polk's statement, Warhol said, "Yes, but I really do all the paintings. We were just being funny. If there are any fakes around I can tell. . . . The modern way would be to do it like that, but I do them all myself." Barry Blinderman, "Modern 'Myths.' "

A similar attitude is displayed by Warhol in a series of photographs which were used as endpapers for Carter Ratcliff's monograph, where Warhol, staring into the camera (or out at the collector), displays to the incredulous the original tools and traces of his martyrium of painting in the way Christ displayed the tools of his in Christian iconography.

58. Quoted in Gidal, *Andy Warhol,* p. 27. According to both Teeny Duchamp and John Cage, Marcel Duchamp was apparently quite fond of Warhol's work (which does not really come as a surprise). See Teeny Duchamp and John Cage, interviewed by David Bailey, in Bailey, *Andy Warhol.*

59. Henry Geldzahler, "A Symposium on Pop Art," ed. Peter Selz, *Arts Magazine* (April 1963): 18 ff. Ten years later, Geldzahler would address the question of the European success of pop art once again, slightly toned down but no less imperialist in attitude, and certainly confusing the course of historical development: "And the question is why would Germany be particularly interested in this American phenomenon and the reason goes back, I think,

to a remark that Gertrude Stein made quite early in the twentieth century which is that America is the oldest country in the world because it entered the twentieth century first and the point really is that the Germans in their postwar boom got into a mood that America was in in the twenties and Andy essentializes the American concentration on over-abundance of commercial objects." The fact is, of course, that the "mood that America was in in the twenties" had been the mood that the Europeans had been in during the twenties as well and which had generated dadaism, the very artistic legacy at the origin of pop art's formation.

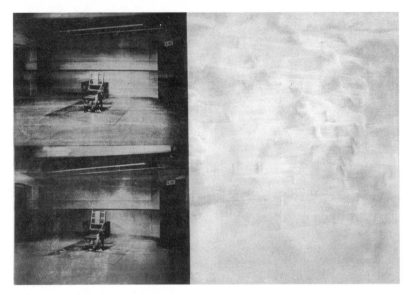

Silver Disaster, 1963. Silkscreen ink on synthetic polymer paint on canvas, 42 × 60 in. The Sonnabend Collection.

Saturday Disasters: Trace and Reference in Early Warhol

Thomas Crow

The public Warhol was not one but, at a minimum, three persons. The first, and by far the most prominent, was the self-created one: the product of his famous pronouncements and of the allowed representations of his life and milieu. The second was the complex of interests, sentiments, skills, ambitions, and passions actually figured in paint on canvas. The third was his persona as it sanctioned experiments in nonelite culture far beyond the world of art.[1] Of these three, the latter two are of far greater importance than the first, though they were normally overshadowed by the man who said he wanted to be like a machine, that everyone would be famous for fifteen minutes, and that he and his art were all surface: don't look any further. The second Warhol is normally equated with the first; and the third, at least by historians and critics of art, is largely ignored.

This essay is primarily concerned with the second Warhol, though this will necessarily entail attention to the first. The conventional reading of his work turns around a few circumscribed themes: the impersonality of the images he chose and their presentation, his passivity in the face of a media-saturated reality, and the suspension in his work of any clear authorial voice. His choice of subject matter is regarded as essentially indiscriminate. Little interest is displayed in his subjects beyond the observation that, in their totality, they represent the random play of a consciousness at the mercy of the commonly available commercial culture. The debate over Warhol centers on whether his art fosters critical or subversive apprehension of mass culture and the power of the image as commodity,[2] succumbs in an innocent but telling way to that numbing power,[3] or exploits it cynically and meretriciously.[4]

A relative lack of concentration on the evidence of the early pictures has made a notoriously elusive figure more elusive than he needs to be—

or better, only as elusive as he intended to be. This discussion could, I think, be recast by addressing a contradiction at its core. The authority normally cited for this observed effacement of the author's voice in Warhol's pictures is none other than that voice itself. It was Warhol who told us that he had no real point to make, that he intended no larger meaning in the choice of this or that subject, and that his assistants did most of the physical work of producing his art. Indeed, it would be difficult to name an artist who has been as successful as Warhol was in controlling the interpretation of his own work.

In the end, any critical account of Warhol's achievement as a painter will necessarily stand or fall on the visual evidence. But even within the public "text" provided by Warhol, there are some less calculated remarks that qualify the general understanding of his early art. One such moment occurs in direct proximity to two of his most frequently quoted pronouncements: "I want everybody to think alike" and "I think everybody should be a machine." In this section of his 1963 interview with Gene Swenson, he is responding to more than the leveling effects of American consumer culture. His more specific concern is rather the meanings normally given to the *difference* between the abundant material satisfactions of the capitalist West and the relative deprivation and limited personal choices of the Communist East. The sentiment, though characterized by the prevailing American image of Soviet Communism, lies plainly outside the cold war consensus: "Russia is doing it under strict government. It's happening here all by itself. . . . Everybody looks alike and acts alike, and we're getting more and more the same way."[5] These words were uttered only a year or so after the Cuban missile crisis and within months of Kennedy's dramatic, confrontational appearance at the Berlin Wall. It was a period marked by heightened ideological tension, in which the contrast of consumer cultures observable in Berlin was generalized into a primary moral distinction between the two economic and political orders. The bright lights and beckoning pleasures of the Kurfürstendamm were cited over and over as an unmistakable sign of Western superiority over a benighted Eastern bloc. One only had to look over the Wall to see the evidence for oneself in the dim and shabby thoroughfare that the once glittering Unter den Linden had become.

In his own offhand way, Warhol was refusing that symbolism, a contrast of radiance and darkness that was no longer, as it had been in the 1950s, primarily theological but had become consumerist in character.

The spectacle of overwhelming Western affluence was the ideological weapon in which the Kennedy administration had made its greatest investment, and it is striking to find Warhol seizing on that image and negating its received political meaning (affluence equals freedom and individualism) in an effort to explain his work. Reading that interview now, one is further struck by the barely suppressed anger present throughout his responses, as well as by the irony in the phrases that would later congeal into the clichés. Of course, to generalize from this in order to impute some specifically politicized intentions to the artist would be to repeat the error in interpretation referred to above—to use a convenient textual crutch to avoid the harder work of confronting the paintings directly. A closer look at such statements as these, however, can at least prepare us for unexpected meanings in the images, meanings possibly more complex or critical than the received reading of Warhol's work would lead us to believe.

The principal thesis of this essay is that Warhol, though he grounded his art in the ubiquity of the packaged commodity, produced his most powerful work by dramatizing the breakdown of commodity exchange. These were instances in which the mass-produced image as the bearer of desires was exposed in its inadequacy by the reality of suffering and death. Into this category, for example, falls his most famous portrait series, that of Marilyn Monroe. He began the pictures within weeks of Monroe's suicide in August 1962, and it is remarkable how consistently this simple fact goes unremarked in the literature.[6] Her death was something with which Warhol clearly had to deal, and the pictures represent a lengthy act of mourning, much of the motivation for which lies beyond our understanding. (Some of the artist's formal choices refer to this memorial or funeral function directly, especially the single impression of her face against the gold background of an icon [*Gold Marilyn Monroe,* Museum of Modern Art], the traditional sign of an eternal other world.) Once undertaken, however, the series raised issues that continue to involve us all. How does one handle the fact of celebrity death? Where does one put the curiously intimate knowledge one possesses of an unknown figure, and how does one come to terms with the sense of loss—the absence of a richly imagined presence that was never really there? For some it might be Monroe, for others Buddy Holly or a Kennedy: the problem is the same.

Any complexity of thought or feeling in Warhol's *Marilyns* may be difficult to discern from our present vantage point. Not only does his myth stand in the way, but the portraits' seeming acceptance of the reduction of

a woman's identity to a mass commodity fetish can make the entire series seem a monument to the benighted past or unrepentant present. Though Warhol obviously had little stake in the erotic fascination felt for her by the male intellectuals of the fifties generation—de Kooning and Mailer, for example[7]—he may indeed have failed to resist it sufficiently in his art. It is far from the intent of this essay to redeem whatever contribution Warhol's pictures have made to perpetuating that mystique. But there are ways in which the majority of the Monroe paintings, when viewed apart from the Marilyn/goddess cult, exhibit a degree of tact, even reverence, that withholds outright complicity with it.

That effect of ironic remove began in the process of creating the silkscreen transfer. Its source is a bust-length publicity still in black and white taken in 1953 for the film *Niagara*.[8] The print that Warhol used, marked for cropping with a grease pencil, survives in the archives of his estate. A face shot in color from the same session was one of the best-known images of the young actress, but Warhol instead opted for a physically smaller segment of one taken at a greater distance from its subject. In its alignment with the four-square rectangle of Warhol's ruled grid, the face takes on a solid, self-contained quality that both answers to the formal order of Warhol's compositional grids and undercuts Monroe's practiced and expected way of courting the male eye behind the camera. An instructive comparison can be made between the effect of Warhol's alteration of his source and James Rosenquist's *Marilyn Monroe I* of 1962 (Museum of Modern Art); for all of the fragmentation and interference that the latter artist imposes on the star portrait, its mannered coquettishness is precisely what he lingers over and preserves.

The beginning of the *Marilyn* series coincides with the moment of Warhol's commitment to the silkscreen technique,[9] and there is a close link between technique and meaning. Compared to the Rosenquist or to the vivid, fine-grained color of the studio face portrait, his manipulation and enlargement of a monochrome fragment drain away much of the imaginary living presence of the star. The inherently flattering and simplifying effects of the transformation from photograph to fabric stencil to inked canvas are magnified rather than concealed. The screened image, reproduced whole, has the character of an involuntary imprint. It is a memorial in the sense of resembling memory: powerfully selective, sometimes elusive, sometimes vividly present, always open to embellishment as well as loss.

In the *Marilyn Diptych* (Tate Gallery), also painted in 1962, Warhol lays out a stark and unresolved dialectic of presence and absence, of life and

death. The left side is a monument; color and life are restored, but as a secondary and invariant mask added to something far more fugitive. Against the quasi-official regularity and uniformity of the left panel, the right concedes the absence of its subject, displaying openly the elusive and uninformative trace underneath. The right panel nevertheless manages subtle shadings of meaning within its limited technical scope. There is a reference to the material of film that goes beyond the repetition of frames. On a simple level, it reminds us that the best and most enduring film memories one has of Monroe—in *The Seven-Year Itch, Some Like It Hot, The Misfits*—are in black and white. The color we add to her memory is supplementary. In a more general sense, she is most real and best remembered in the flickering passage of film exposures, not one of which is ever wholly present to perception. The heavy inking in one vertical register underscores this. The passage from life to death reverses itself; she is most present where her image is least permanent. In this way, the *Diptych* stands as a comment on and complication of the embalmed quality, the slightly repellent stasis, of the *Gold Marilyn*.

Having taken up the condition of the celebrity as trace and sign, it is not surprising that Warhol would soon move to the image of Elizabeth Taylor. She and Monroe were nearly equal and unchallenged as Hollywood divas with larger-than-life personal myths. Each was maintained in her respective position by a kind of negative symmetry with the other, by representing what the other was not.

He then completed his triangle of female celebrity for the early 1960s with a picture of Jacqueline Kennedy in the same basic format as the full-face portraits of Monroe and Taylor. The president's wife did not share film stardom with Monroe, but she did share the Kennedys. She also possessed the distinction of having established for the period a changed feminine ideal. Her slim, dark, aristocratic standard of beauty had made Monroe's style, and thus her power as a symbol, seem out of date even before her death. (That new standard was mimicked within the Warhol circle by Edie Sedgewick, for a time his constant companion and seeming alter ego during the period.) Warhol reinforced that passé quality by choosing for his series a photograph of Monroe from the early 1950s; by that simple choice, he measured a historical distance between her life and her symbolic function, while avoiding the signs of aging and mental collapse.

The semiotics of style that locked together Warhol's images of the three women represents, however, only one of the bonds between them.

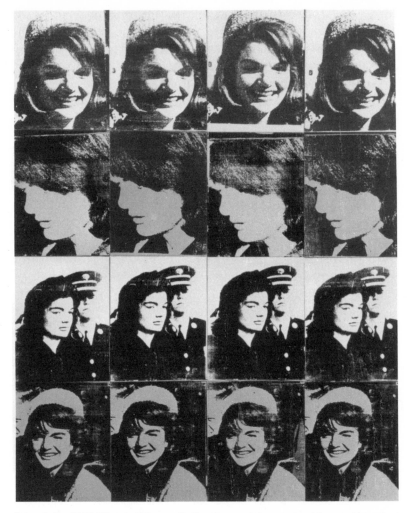

Sixteen Jackies, 1964. Silkscreen ink on synthetic polymer paint on canvas; sixteen panels, each
20 × 16 in., overall 80 × 64 in. Walker Art Center, Minneapolis.

The other derived from the threat or actuality of death. The full-face por-
traits of the *Liz* series, though generated by a transformation of the *Mari-
lyns,* in fact had an earlier origin. Taylor's famous catastrophic illness in
1961—the collapse that interrupted the filming of *Cleopatra*—had entered
into one of Warhol's early tabloid paintings, *Daily News* (1962). The con-
temporaneous rhythm of crises in the health of both women had joined
them in the public mind (and doubtless Warhol's as well) in that year; it was

a bond that the third would come to share in November 1963. The Kennedy assassination pictures are often seen as an exception in the artist's output, exceptional in their open emotion and sincerity,[10] but their continuity with the best of his previous work seems just as compelling. As with the *Marilyns,* the loss of the real Kennedy referent galvanizes Warhol into a sustained act of remembrance. Here, however, he has a stand-in, the widow who had first attracted him as an instance of celebrity typology. Again, he limits himself to fragmentary materials, eight grainy news photographs out of the myriad representations available to him. These he shuffles and rearranges to organize his straightforward expressions of feeling: in *Nine Jackies* of 1964 (Sonnabend Collection), one sees the irrevocable transformation of the life of the survivor, Jackie happy and Jackie sad, differentiated by the color of the panel; the print *Jackie H* of 1966 uses a simple doubling within one undivided field both to multiply the marks of stoicism and grief and to make the widow less solitary in her mourning. The emotional calculus is simple, the sentiment direct and uncomplicated. The pictures nevertheless recognize, by their impoverished vocabulary, the distance between public mourning and that of the principals in the drama. Out of his deliberately limited resources, the artist creates a nuance and subtlety of response that is his alone, precisely because he has not sought technically to surpass his raw material. It is difficult not to share in this, however cynical one may have become about the Kennedy presidency or the Kennedy marriage. In his particular dramatization of medium, Warhol found room for a dramatization of feeling and even a kind of history painting.

My reading of Warhol has thus far proceeded by establishing relationships among his early portraits. It can be expanded to include the apparently anodyne icons of consumer products for which the artist is equally renowned. Even those familiar images take on unexpected meanings in the context of his other work of the period. For example, in 1963, the year after the Campbell's soup can imagery had established his name, Warhol did a series of pictures under the title *Tunafish Disaster.* These are, understandably enough, lesser-known works, but they feature the repeated images of an analogous object, a can of A&P-brand tuna. In this instance, however, the contents of the can were suspected of having killed people, and newspaper photographs of the victims are repeated below those of the deadly containers. The wary smile of Mrs. McCarthy, the broad grin of Mrs. Brown, as each posed with self-conscious sincerity for their snapshots, and the look of the clothes, glasses, and hairstyles speak the language

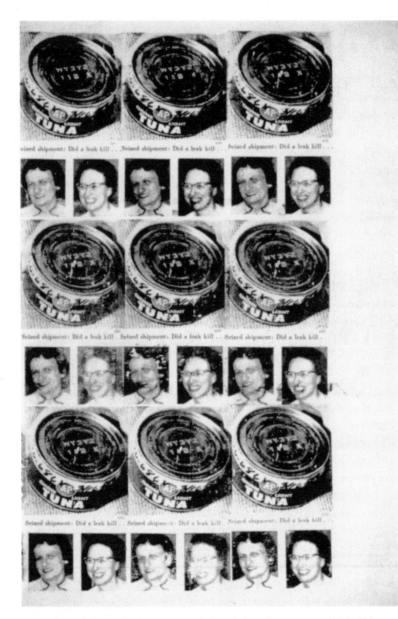

Tunafish Disaster, 1963. Silkscreen ink on synthetic polymer paint on canvas, 124⅜ × 83 in. Saatchi Collection, London.

of class in America. The women's workaday faces and the black codings penned on the cans transform the mass-produced commodity into anything but a neutral abstraction.

More than this, of course, the pictures commemorate a moment when the supermarket promise of safe and abundant packaged food was disastrously broken. Does Warhol's rendition of the disaster render it safely neutral? I think not, no more than it would be possible for an artist to address the more recent panics over tampering with nonprescription medicines without confronting the kinds of anxiety they express. In this case, the repetition of the crude images does force attention to the awful banality of the accident and the tawdry exploitation by which we come to know the misfortunes of strangers, but it does not mock attempts at empathy, however feeble. Nor do the images direct our attention to some peculiarly twentieth-century estrangement between the event and its representation: the misfortunes of strangers have made up the primary content of the press since there has been a press. The *Tunafish Disaster* pictures take an established feature of pop imagery, established by others as well as by Warhol, and push it into a context decidedly other than that of consumption. We do not consume the news of these deaths in the same way that we consume the safe (one hopes) contents of a can.

Along similar lines, a link can be made to the several series that use photographs of automobile accidents. These commemorate events in which the supreme symbol of consumer affluence, the American car of the 1950s, has ceased to be an image of pleasure and freedom and has become a concrete instrument of sudden and irreparable injury. (In only one picture of the period, *Cars,* does an automobile appear intact.) Does the repetition of *Five Deaths* or *Saturday Disaster* cancel attention to the visible anguish in the faces of the living or the horror of the limp bodies of the unconscious and dead? We cannot penetrate beneath the image to touch the true pain and grief, but their reality is sufficiently indicated in the photographs to force attention to one's limited ability to find an appropriate response. As for the repetition, might we just as well understand it to mean the grim predictability, day after day, of more events with an identical outcome, the leveling sameness with which real, not symbolic, death erupts in our experience?

In his selection of these photographs, Warhol was as little as ever the passive receptor of commonly available imagery. Rather than relying upon newspaper reproductions that might have come to hand randomly, he sought out glossy press agency prints normally seen only by professional

journalists.[11] (Some of these photographs were apparently regarded as too bizarre or gruesome ever to see print; that is, they were barred from public reproduction precisely because of their capacity to disturb.) These series have in common with the celebrity portraits and product labels discussed above a fascination with moments where the brutal fact of death and suffering cancels the possibility of passive and complacent consumption. And Warhol would take this further. Simultaneously with his first meditations on the Monroe death, Warhol took up the theme of anonymous suicide in several well-known and harrowing paintings. *Bellevue I* (1963) places the death within a context of institutional confinement. And again the argument could be offered that the repetition of the photographic image within the pictorial field can increase rather than numb sensitivity to it, as the viewer works to draw the separate elements into a whole. The compositional choices are artful enough to invite that kind of attention. Take, for example, the way the heavily inked units in the upper left precisely balance and play off the void at the bottom. That ending to the chain of images has a metaphoric function akin to the play of presence and absence in the *Marilyn Diptych*—it stands in a plain and simple way for death and also for what lies beyond the possibility of figuration.[12] In the 1962 print on paper *Suicide,* the implacable facade of the building from which the victim has jumped (we can see neither its top nor its bottom) becomes an area of obscure abstraction marked only by dim ranks of unseeing windows; it is the dark complement to the bright wedge that surrounds the leaper's horrific silhouette.

The electric chair pictures, as a group, present a similarly stark dialectic of fullness and void. But the dramatic shifts between presence and absence are far from being the manifestation of a pure play of the signifier liberated from reference beyond the sign; they mark the point where the brutal fact of violent death entered the realm of contemporary politics. The early 1960s, following the execution of Caryl Chessman in California, had seen agitation against the death penalty grow to an unprecedented level of intensity.[13] The partisan character of Warhol's images is literal and straightforward, as he is wont to be, and that is what saves them from mere morbidity. He gave them the collective title *Disaster,* and thus tied a political subject to the slaughter of innocents in the highway, airplane, and supermarket accidents he memorialized elsewhere. He was attracted to the open sores in American political life, the issues that were most problematic for liberal Democratic politicians such as Kennedy and Edmund Brown. At this time he also did a series on the most violent phase of civil rights

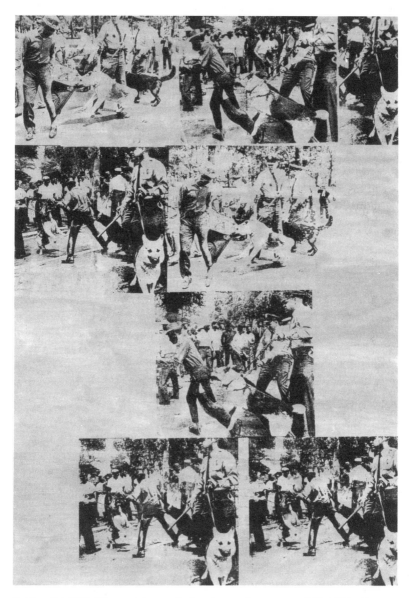

Red Race Riot, 1963. Silkscreen ink on synthetic polymer paint on canvas, 137 × 82½ in. Museum Ludwig, Cologne.

demonstrations in the South; in the *Race Riots* of 1963, political life takes on the same nightmare coloring that saturates so much of his other work.

We might take seriously, if only for a moment, Warhol's dictum that in the future everyone will be famous for fifteen minutes, but conclude that in his eyes it was likely to be under fairly horrifying circumstances. What this body of paintings adds up to is a kind of *peinture noire* in the sense that we apply the term to the *film noir* genre of the 1940s and early 1950s— a stark, disabused, pessimistic vision of American life, produced from the knowing rearrangement of pulp materials by an artist who did not opt for the easier paths of irony or condescension.

By 1965, of course, this episode in his work was largely over; the *Flowers, Cow Wallpaper,* silver pillows, and the like have little to do with the imagery under discussion here. Then the clichés began to ring true. But there was for a time, in the work of 1961 to 1964, a threat to create a true "pop" art in the most positive sense of that term—a pulp-derived, bleakly monochrome vision that held, however tenuous the grip, to an all-but-buried tradition of truth-telling in American commercial culture. Very little of what is normally called pop art could make a similar claim. It remained, one could argue, a latency subsequently taken up by others, an international underground soon to be overground, who created the third Warhol and the best one.

Discussion

AUDIENCE I'm very impressed with your presentation of the early Warhol, and I think that your talk was not only interesting, but in fact very close to what Warhol was actually doing during the period in question. It is hard to reconcile what he has done afterward with his early stuff. I wonder if you could speculate on why that tremendous shift happened?

THOMAS CROW Well, the simple answer would be no. I haven't a clue why he changed; why he became this bizarre, right-wing media creature (and a very wealthy man, with his publishing enterprise and steady line in celebrity portraits and so on). It's hard to say. I think that the pictures that I've been talking about have everything to do with where Warhol came from: a working-class, disorganized early life in Pennsylvania, many details of which are unknown. He was a man with a kind of loyalty to his origins that lasted a little while and then was shed.

AUDIENCE Would it be possible, since Warhol was focusing in on celebrities, that his own growing celebrity status disillusioned him a great deal? I ask this because a lot of the criticism of his work at the time these pictures were introduced was not about what you've been talking about. You've been talking about the sincerity and the horror and the *film noir* aspects of his work, whereas a lot of the criticism of Warhol at the time that you're referring to was about Warhol as a full person.

THOMAS CROW Yes, the game may have just worked so well . . . though I do see a lot of the things that he verbally claimed about his art to be a kind of defense mechanism about their rather embarrassing elemental and sincere qualities. Of course, you can't underestimate the assassination attempt either, in which all of this came true in his life, and the kind of fear, disillusionment, and pain—terrible lengthy pain—that caused him. That would change anybody.

AUDIENCE I'd like to ask you something to do with what you said about Warhol's treatment of the subject of Marilyn, where the words that stuck in my mind were "reverence" and "tact." Can you clarify what you mean by that? My reaction is to say that they are irreverent and tactless.

THOMAS CROW This may just come down to an irreducible difference in our senses of the way that Monroe is being presented. I think that one way to begin an answer to the question is to start comparing the way that she appears in Warhol's work to the way that she gets taken up in the hands of other artists, or to the way that she has been turned into a kind of publishing industry of reproductions of her image ever since. There's that picture by Rosenquist in which she appears in one of those pin-up poses, tossing her head back and smiling, obviously trying to please the camera, please the viewer. Warhol took a lot of what we take to be the normal signs of glamour and of seductiveness out of the picture. I think that the qualities of a certain kind of respect for Monroe, and for what she symbolized, are much more apparent where she's not covered by color than where she is. And I think that there is a layering there in which one is asked to attend to the fact that there is a deeper layer underneath the color, one that can change and shift and that occasionally gets exposed, as it does in the Monroe diptych.

AUDIENCE Do you really think there was a difference for Warhol between Marilyn and what she symbolized?

THOMAS CROW Oh yes, absolutely. I think that Warhol sensed it. Biographical data is going to be no confirmation for this argument, but the man had spent ten years in the fashion industry, in which keeping your finger on the slightest seismic tremors having to do with stylistic signs and distinctions is what you do to survive. And to think that he would be producing Monroe as some univalent symbol of sexuality or of Hollywood seems to be at odds with everything one would expect from the man. So I think that one starts to look for complications, and these are the ones that I see in the image. I don't think that the *Gold Marilyn* is a mockery. The image does have something of the overpretty and of the slightly repellent character of an embalming, but that is our funerary ritual, isn't it? I mean, in most of American life, that embalming, though it repels everyone, is still adhered to. That would be a way of constructing irreverence too, in a way that would allow for its slightly perverse qualities. But they're not images that are about pandering, except maybe the *Lips*. And, although it's not an ironclad connection, I'm struck by the de Kooning parallel there.

THIERRY DE DUVE This is a very interesting debate. It makes me a little bit uncomfortable with the subject strategy that you have developed, presenting a humanistic view of early Warhol, and that is why I am hungry for more information about how you explain the shift that is supposedly occurring in 1965. I myself don't see so much difference between a pure, working-class boy making his way through advertising to become a high art figure and then the cynical superstar that he has become since then. Maybe symmetrical to this historical problem, or going hand in hand with it, there is the problem that the discussion is now framed between respect and irrespect, appropriation and mourning, and things like that. I feel a little bit uncomfortable with that.

I would, for example, suggest another track to thinking about Marilyn. As you know, for the year or so before her death, Marilyn spoke of her own image in absolutely schizophrenic terms. She could not deal with her own image and referred to her own photographs of herself as "this woman." Warhol may be the one person who has understood, consciously or not I don't know, that to be a star is to be a blank screen. He has lived by that. A blank screen for the projection of spectators' phantasmas, dreams, and desires. The connection between Eros and Thanatos in his work is indeed an extremely poignant thing, which I am afraid cannot be dissociated. You seem to think that his saying that he's "just surface," "I want to be a machine," and all that, is a foil, or is a defense system. Why do his private im-

age and his public image coincide so well, then? And why has he been able to sustain a life for more than twenty years like that, and an art practice which, even if it is recuperated, is still of relatively good quality?

THOMAS CROW I should try to craft a kind of simple response to the complex of things that you raised. In one sense, I beg off dealing with the problem of Warhol's biography even by the standard I tried to set in the talk itself. Which is to say that trying to think of Warhol as a character, as a media personality, has been a trap for interpretation. As long as this kind of thinking has gone on, the actual character of the work has been relatively neglected. One thing that one has to say to all of this business of Monroe's understanding that she was an image, and Warhol's being sensitive to this, and so on, is that he didn't have to be all that sensitive to be able to use those ideas: it was in *Life* magazine. There was a long interview, in fact, which happened by coincidence to be published the very week that she died, in which she used her education of the last ten years or so to reflect on all of these issues. It was part of the culture; it wasn't something that the artistic sophisticate had to supply to mass culture. It was there, and Warhol was just interested in it and able to make some painting out of it.

THIERRY DE DUVE "Interested" is too weak a word; I think that it's a matter of an extraordinarily strong desire on the side of the death drive. He is touching on the pleasure that people derive from what makes other people suffer. Marilyn kills herself, and Warhol derives that strange pleasure out of it.

THOMAS CROW We're getting into a level of psychoanalytic exploration that I just fear to follow.

THIERRY DE DUVE Not really, it also has to do with surfaces, images, makeup, to be a strip of film, to have one's body employed by the movie industry. The body doesn't count because the body is mortal, but the image is immortal. So how can one convert that psychic and desire economy into magnificent paintings which transform these things into a pleasure?

AUDIENCE I do have a problem with the presentation. This is because it does not really deal with the whole convention of disorder, the whole notion of the "aura" or of the authenticity of the work of art. How does Warhol's work relate to that? And how does Warhol's work relate to the image of the star? . . . To real subjectivity? . . . To real humanity? . . . To what a real woman is as opposed to what her image is? . . . None of that

stuff was really addressed, and I think that all of that was really an issue on the screen, working and presenting the images.

In my reading of the 1960s, there is talk of how there was this tremendous barrage of imagery which people were confronted with every day, such as the war, race riots, car crashes, and so on. The result was a highly intellectual combat with television. So there was this resulting desensitization, and that's why you get "hot" imagery that takes the form of images like Marilyn. I just think that all of that is perhaps more of a sociological phenomenon.

THOMAS CROW To me, that just sounds like journalism that needs to be interrogated. To elide things like racial clashes with car crashes, say, would be just to talk about them on one plane as being part of some image saturation. This seems to be very incurious about where such images come from, and where they're most likely to be taken seriously.

The images of car crashes are the staple of small-town journalism. They are about local people you might know, they are about very intimate forms of disaster that can erupt in a town. I remember them from my own childhood as being something to which you were exposed all the time. Maybe you could try a macrosociological explanation that, with the great increase in car ownership in the 1950s, cars that were just rolling death traps, no safety devices at all, people were really being killed, and it was an intimate form of confrontation with terrible danger that was a part of everyday life. It didn't have anything to do with the 1960s and some kind of image saturation; it was a localized and very modest kind of media phenomenon.

I don't know, do you all feel overwhelmed now? I mean, it's bound to have gotten worse in the meantime. Do you carry around this feeling that your consciousness has been completely leveled by news of Lebanon, and Nicaragua, and hijackings so that you can't think anymore? . . . So that discriminations are impossible? Granted that it's a complicated thing, but you can still think.

Notes

1. There are as yet only fragmentary accounts of this phenomenon. For some preliminary comment, see Iain Chambers, *Urban Rhythms: Pop Music and Popular Culture* (New York: St. Martin's Press, 1985), pp. 130ff.

2. See, for example, Rainer Crone, *Andy Warhol,* trans. J. W. Gabriel (New York: Praeger, 1970), passim.

3. See, for example, Carter Ratcliff, *Andy Warhol* (New York: Abbeville Press, 1983), passim. For an illuminating discussion of the power and effects of this view in West Germany, see Andreas Huyssen, "The Cultural Politics of Pop," *New German Critiques* 4 (Winter 1975): 77–98.

4. See, for example, Robert Hughes, "The Rise of Andy Warhol," in B. Wallis, ed., *Art after Modernism* (New York: New Museum of Contemporary Art; Boston: D. R. Godine, 1984), pp. 45–57.

5. Andy Warhol, "What Is Pop Art?" interview by Gene Swenson, *Art News* 62 (November 1963): 26. Warhol's assistant during the 1960s, Gerard Malanga, offered this interpretation of the passage in an interview: "Well, Andy's always said . . . he said somewhere that he thought of himself as apolitical. And if you remember reading that really good interview with Andy by Gene Swenson in '63, in *Art News,* when Andy talks about capitalism and communism as really being the same thing and someday everybody will think alike—well, *that's* a very political statement to make even though it sounds very apolitical. So, I think, there was always a political undercurrent to Andy's unconscious concern for politics, or of [*sic*] society for that matter." (Patrick S. Smith, *Warhol: Conversations about the Artist* (Ann Arbor: UMI Research Press, 1988), p. 163.

6. Crone (*Andy Warhol,* p. 24) dates the beginning of the Monroe portraits in a discussion of silkscreen technique without mentioning the death. Ratcliffe (*Andy Warhol,* p. 117) dates the first portraits to August in a brief chronology appended to his text, also without mentioning Monroe's death in the same month.

7. De Kooning titled one of his *Woman* series after her in 1954. Norman Mailer's fascination with the actress is rehearsed at length in *Marilyn, a Biography* (New York: Grosset & Dunlap, 1973). Warhol was himself fascinated by the aura that surrounded the artists of the first generation of the New York School and was calculatedly looking for ways to move into their orbit. His interest in de Kooning, though no doubt real, has taken on a spurious specificity based on remarks mistakenly appended to the 1963 Swenson interview when it was reprinted in John Russell and Suzi Gablik, *Pop Art Redefined* (New York: Praeger, 1969). The statement (p. 188), "de Kooning gave me my content and my motivation," actually comes from Swenson's interview with Tom Wesselmann (see *Art News* 62 [February 1964]: 64). Like others, I had given credence to this scholarly virus in the past. The record was publicly corrected by Barry Blinderman (letter to the editor, *Art in America* 75 [October 1987]: 21). The misattribution has, however, reappeared in the catalogue of the Museum of Modern Art exhibition, *Andy Warhol: A Retrospective* (New York: Museum of Modern Art; Boston: distributed by Bullfinch Press/Little, Brown, 1989), pp. 18, 23n.

8. The print, from a photograph by Gene Kornman, was uncovered in the archives of the Warhol estate by the organizers of *Andy Warhol: A Retrospective* (an illustration of the print with Warhol's markings appears on p. 72). Before it had come to light, I had surmised that he had used a portion of the color face portrait in a composite image, basing that conjecture on the seemingly identical aspect of the hair in that photograph and in the Warhol screen (see my comments and an illustration of the other portrait in *Art in America* 75 [May 1987]: 130). I am grateful to Jennifer Wells of the department of painting at the Museum of Modern Art for her knowledge and assistance on this and other points.

9. See Crone, *Andy Warhol,* p. 24, who dates Warhol's commitment to the technique to August 1962. The first screened portraits, he states, were of Troy Donahue. Marco Livingston ("Do It Yourself: Notes on Warhol's Techniques," in *Andy Warhol: A Retrospective,* p. 69) states that *Baseball* (Nelson-Atkins Museum, Kansas City) was among the very earliest, along with *Disasters* on both paper and canvas, such as *Suicide* (Adelaide de Menil Collection).

10. See, for example, *Andy Warhol* (Greenwich, Conn.: New York Graphic Society, 1970), p. 52. The source of most of the photographs was *Life* 55 (November 29, 1963): 22, 31; (December 6, 1963): 43, 48.

11. See interview with Gerard Malanga in Smith, *Warhol: Conversations about the Artist,* p. 163.

12. This control, of course, could take the form of understanding and anticipating the characteristic imperfections and distortions of the process; that is, of knowing just how little one had to intervene once the basic arrangement, screen pattern, and color choices had been decided. For a firsthand account, see the illuminating if somewhat self-contradictory comments of Gerard Malanga in Patrick S. Smith, *Andy Warhol's Art and Films* (Ann Arbor: UMI Research Press, 1986), pp. 391–392, 398–400. See also Livingston's remarks ("Do It Yourself," p. 72) on the ways in which the rephotographed full-sized acetate would be altered by the artist ("for example, to increase the tonal contrast by removing areas of half-tone, thereby further flattening the image") before its transfer to silkscreen, as well as on the subsequent use of the same acetate to plot and mark the intended placement of the screen impressions before the process of printing began. Warhol's remarks in a conversation with Malanga indicate a habit of careful premeditation; he explains how the location of an impression was established if color was to be applied under it: "Silhouette shapes of the actual image were painted in by isolating the rest of an area on the canvas by means of masking tape. Afterwards, when the paint dried, the masking tape would be removed and the silk screen would be placed on top of the painted silhouette shape, sometimes slightly off register." *Print Collector's Newsletter* 1 (January/February 1971): 126.

13. For a summary of press accounts of the affair, see Roger E. Schwed, *Abolition and Capital Punishment: The United States' Judicial, Political and Moral Barometer* (New York: AMS Press, 1983), pp. 68–104.

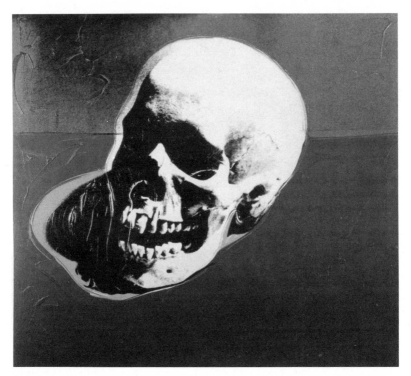

Skull, 1976. Silkscreen ink on synthetic polymer paint on canvas, 132 × 150 in. The Dia Art Foundation, New York.

Death in America

Hal Foster

The human organism is an atrocity exhibition at which he is an un-
willing spectator.

—*J. G. Ballard,* The Atrocity Exhibition

In *The Philosophy of Andy Warhol* (1975), the great idiot savant of our time
chats about many big subjects—love, beauty, fame, work—but when it
comes to death, this is all he has to say: "I don't believe in it because you're
not around to know that it's happened. I can't say anything about it be-
cause I'm not prepared for it."[1] On first hearing, there is not much in this
stony demurral (which has little of the light wit of the rest of the book);
yet listen again to these phrases: "not around to know . . . can't say any-
thing . . . not prepared." There is a break in subjectivity here, a disorienta-
tion of time and space. To me it suggests an experience of shock or trauma,
an encounter where one misses the real, where one is too early or too late
(precisely "not around," "not prepared"), but where one is somehow
marked by this very missed encounter.

I fix on this idiosyncratic passage because I think it encrypts a relation
to the real that suggests a new way into Warhol, especially into the *Death
in America* images from the early 1960s, one that may get us beyond the old
opposition that constrains so many approaches to the work: that the im-
ages are attached to referents, to iconographic themes or to real things in
the world, or, alternatively, that the world is nothing but image, that all pop
images in particular represent are other images.[2] Most readings not only of
Warhol but of postwar art based in photography divide somewhere along
this line: the image as referential *or* as simulacral. This is a reductive ei-
ther/or that a notion of traumatic realism may open up productively.[3]

Traumatic Realism

It is no surprise that the *simulacral* reading of Warholian pop is advanced by
critics associated with poststructuralism, for whom Warhol is pop and,
more importantly, for whom the theory of the simulacrum, crucial as it is
to the poststructuralist critique of representation, sometimes seems to de-
pend on the example of Warhol as pop. "What Pop art wants," Roland
Barthes writes in "That Old Thing, Art" (1980), "is to desymbolize the
object," that is, to release the image from deep meaning (metaphoric asso-
ciation or metonymic connection) into simulacral surface.[4] In the process,
the author is also released: "The Pop artist does not stand *behind* his work,"
Barthes continues, "and he himself has no depth: he is merely the surface
of his pictures, no signified, no intention, anywhere."[5] With variations, this
reading of Warholian pop is performed by Michel Foucault, Gilles
Deleuze, and Jean Baudrillard, for whom referential depth and subjective
interiority are also victims of the sheer superficiality of pop. In "Pop—An
Art of Consumption?" (1970), Baudrillard agrees that the object in pop
"loses its symbolic meaning, its age-old anthropomorphic status."[6] But
where Barthes and company see an avant-gardist disruption of representa-
tion, Baudrillard sees an "end of subversion," a "total integration" of the
artwork into the political economy of the commodity sign.[7]

The *referential* view of Warholian pop is advanced by critics and his-
torians who tie the work to different themes: the worlds of fashion,
celebrity, gay subculture, the Warhol Factory, and so on. Its most intelligent
version is presented by Thomas Crow, who, in "Saturday Disasters: Trace
and Reference in Early Warhol" (1987), disputes the simulacral account of
Warhol that the images are indiscriminate and the artist impassive. Under-
neath the glamorous surface of commodity fetishes and media stars, Crow
finds "the reality of suffering and death"; the tragedies of Marilyn, Liz, and
Jackie in particular are said to prompt "straightforward expressions of feel-
ing."[8] Here Crow finds not only a referential object *for* Warhol but an em-
pathetic subject *in* Warhol, and here he locates the criticality of Warhol
not in an attack on "that old thing, art" (as Barthes would have it) through
an embrace of the simulacral commodity sign (as Baudrillard would have
it), but rather in an exposé of "complacent consumption" through "the
brutal fact" of accident and mortality.[9] In this way Crow pushes Warhol
beyond humanist sentiment to political engagement. "He was attracted to
the open sores in American political life," Crow writes in a reading of the

electric chair images as agit-prop against the death penalty and of the race riot images as a testimonial for civil rights. "Far from . . . a pure play of the signifier liberated from reference," Warhol belongs to the popular American tradition of "truth-telling."[10]

This reading of Warhol as empathetic, even *engagé,* is a projection (an essay could be written on the desire of left critics to make Warhol over into a contemporary Brecht). But it is no more a projection than the superficial, impassive Warhol, even though this projection was his own: "If you want to know all about Andy Warhol, just look at the surface of my paintings and films and me, and there I am. There's nothing behind it."[11] Both camps make the Warhol they need, or get the Warhol they deserve; no doubt we all do. (What is it, by the way, that renders Warhol such a site for projection? He posed as a blank screen, to be sure, but Warhol was very aware of these projections, indeed very aware of identification *as* projection; it is one of his great subjects.)[12] In any case, neither projection is wrong; but they cannot both be right . . . or can they? Can we read the *Death in America* images as referential *and* simulacral, connected *and* disconnected, affective *and* affectless, critical *and* complacent? I think we must, and I think we can if we read them in a third way, in terms of traumatic realism.

One way to develop this notion is through the famous motto of the Warholian persona: "I want to be a machine."[13] Usually this statement is taken to confirm the blankness of artist and art alike, but it may point less to a blank subject than to a shocked one, who takes on the nature of what shocks him as a mimetic defense against this shock: I am a machine too, I make (or consume) serial product images too, I give as good (or as bad) as I get. "Someone said my life has dominated me," Warhol told Gene Swenson in the celebrated interview of 1963. "I liked that idea."[14] Here Warhol has just confessed to eating the same lunch every day for the past twenty years (what else but Campbell's soup?). In context, then, the two statements read as a preemptive embrace of the compulsion to repeat, put into play by a society of serial production and consumption.[15] If you can't beat it, Warhol suggests, join it. More, if you enter it totally, you might expose it; that is, you might reveal its automatism, even its autism, through your own excessive example. Used strategically in Dada, this capitalist nihilism was performed ambiguously by Warhol, and many artists have played it out since.[16] (This is a performance, of course: there is a subject "behind" this figure of nonsubjectivity who presents it *as* a figure. Otherwise the

shocked subject is an oxymoron, for, strictly speaking, there is no subject in shock, let alone in trauma. And yet the fascination of Warhol is that one is never certain about this subject "behind": is anybody home, inside the automaton?)

These notions of shocked subjectivity and compulsive repetition reposition the role of *repetition* in the Warhol persona and images. "I like boring things" is another famous motto of this quasi-autistic persona. "I like things to be exactly the same over and over again."[17] In *POPism* (1980), Warhol glossed this embrace of boredom, repetition, domination: "I don't want it to be essentially the same—I want it to be *exactly* the same. Because the more you look at the same exact thing, the more the meaning goes away, and the better and emptier you feel."[18] Here repetition is both a draining of significance and a defending against affect, and this strategy guided Warhol as early as the 1963 interview: "When you see a gruesome picture over and over again, it doesn't really have any effect."[19] Clearly this is one function of repetition: to repeat a traumatic event (in actions, in dreams, in images) in order to integrate it into a psychic economy, a symbolic order. But the Warhol repetitions are not restorative in this way; they are not about a mastery of trauma.[20] More than a patient release from the object in mourning, they suggest an obsessive fixation on the object in melancholy. Think of all the *Marilyns* alone, of all the cropping, coloring, and crimping of these images: as Warhol works over this image of love, the "hallucinatory wish-psychosis" of a melancholic seems to be in play.[21] But this analysis is not right either. For one thing, the repetitions not only *re*produce traumatic effects; they *produce* them as well (at least they do in me). Somehow in these repetitions, then, several contradictory things occur at the same time: a warding away of traumatic significance *and* an opening out to it, a defending against traumatic affect *and* a producing of it.

Here I should make explicit the theoretical model I have implicated so far. In the early 1960s, Jacques Lacan was concerned to define the real in terms of trauma. Titled "The Unconscious and Repetition," this seminar was roughly contemporaneous with the *Death in America* images (it ran in early 1964).[22] But unlike the theory of simulacra in Baudrillard and company, the theory of trauma in Lacan was not influenced by pop. It was, however, informed by surrealism, which has its deferred effect on Lacan here, an early associate of the surrealists; and pop is related to surrealism as a traumatic realism (certainly my reading of Warhol is a surrealist one). In this seminar, Lacan defines the traumatic as a missed encounter with the

real. As missed, the real cannot be represented; it can only be repeated, indeed it *must* be repeated. "*Wiederholen,*" Lacan writes in etymological reference to Freud on repetition, "is not *Reproduzieren*"; repetition is not reproduction.[23] This can stand as an epitome of my argument too: repetition in Warhol is not reproduction in the sense of representation (of a referent) or simulation (of a pure image, a detached signifier). Rather, repetition serves to *screen* the real understood as traumatic. But this very need *points* to the real, and it is at this point that the real *ruptures* the screen of repetition. It is a rupture not in the world but in the subject; or rather it is a rupture between perception and consciousness of a subject *touched* by an image. In an allusion to Aristotle on accidental causality, Lacan calls this traumatic point the *tuché;* [24] in *Camera Lucida* (1980), Barthes calls it the *punctum.* "It is this element which rises from the scene, shoots out of it like an arrow, and pierces me," Barthes writes. "It is what I add to the photograph and what is nonetheless already there." "It is acute yet muffled, it cries out in silence. Odd contradiction: a floating flash."[25] (This confusion about the location of the rupture, *tuché,* or *punctum* is a confusion between subject and world, inside and outside. It is an aspect of trauma; indeed, it may be this confusion that is traumatic. "Where Is Your Rupture?" Warhol asks in a 1960 painting of a newspaper advertisement of a nude female torso.)

In *Camera Lucida,* Barthes is concerned with straight photographs, so he relates the *punctum* to details of content. This is rarely the case in Warhol. And yet there is a *punctum* for me (Barthes stipulates that it is a personal effect) in the indifference of the passerby in *White Burning Car III* (1963). This indifference to the crash victim impaled on the telephone pole is bad enough, but its repetition is *galling,* and this points to the general operation of the *punctum* in Warhol. It works less through content than through technique, especially through the "floating flashes" of the silkscreen process, the slipping and streaking, blanching and blanking, repeating and coloring of the images. To take another instance, a *punctum* arises for me less from the slumped woman in the top image in *Ambulance Disaster* (1963) than from the obscene tear that effaces her head in the bottom image. Just as the *punctum* in Gerhard Richter lies less in details than in the pervasive blurring of the image, so the *punctum* in Warhol lies less in details than in this repetitive "popping" of the image.[26]

These pops, such as the slipping of the register of the image and the washing of the whole in color, serve as visual equivalents of our missed encounters with the real. "What is repeated," Lacan writes, "is always

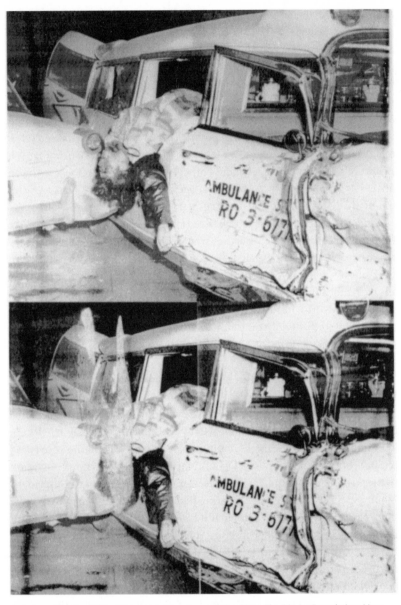

Ambulance Disaster, 1963. Silkscreen ink on canvas, 119 × 80 in. The Dia Art Foundation, New York.

something that occurs . . . *as if by chance.*"[27] And so it is with these pops: they seem accidental, but they also appear repetitive, automatic, even technological (the relation between accident and technology, crucial to the discourse of shock, is another great subject of Warhol).[28] In this way, Warhol elaborates on our optical unconscious, a term introduced by Walter Benjamin to describe the subliminal effects of modern technologies of the image. Benjamin developed this notion in the early 1930s, in response to photography and film; Warhol updates it thirty years later, in response to the postwar society of the spectacle, of mass media and commodity signs.[29] In these early images, we see what it looks like to dream in the age of television, *Life,* and *Time;* or rather, what it looks like to nightmare as shock victims who prepare for disasters that have already come, for Warhol selects moments when this spectacle cracks (the JFK assassination, the Monroe suicide, racist attacks, car wrecks), but cracks only to expand.[30]

Content in Warhol is thus not trivial (Crow is absolutely right here). A white woman slumped from a wrecked ambulance, or a black man attacked by a police dog, is a shock. But, again, it is this first order of shock that the repetition of the image serves to screen, even if in doing so the repetition produces a second order of trauma, here at the level of technique where the *punctum* breaks through the screen and allows the real to poke through. The real, Lacan puns, is troumatic, and again the tear in *Ambulance Disaster* is such a hole for me, though what loss is figured there I cannot say. Through these pokes or pops we seem almost to touch the real, which the repetition of the image at once distances and rushes toward us. Sometimes the coloring of the images has this strange double effect as well.[31]

In this way, different kinds of repetition are put into play by Warhol: repetitions that fix on the traumatic real, that screen it, that produce it. And this multiplicity makes for the Warholian paradox not only of images that are both affective and affectless, but also of viewers that are neither integrated (which is the ideal of most modern aesthetics: the subject composed in contemplation) nor dissolved (which is the effect of much popular culture: the subject given over to the schizo intensities of the commodity sign). "I never fall apart," Warhol remarks in *The Philosophy of Andy Warhol,* "because I never fall together."[32] Such is the subject-effect of his work, too, and it resonates in some art after pop as well: some photorealism, some appropriation art, some object art today. In other words, there is a genealogy of traumatic realism, and it has surfaced strongly in the present.[33]

Mass Witnessing

Barthes was wrong to suggest that the *punctum* is only a private affair; it can have a public dimension as well. The breakdown of the distinction between private and public is traumatic, too; again, understood as a breakdown of inside and outside, it is one way to understand trauma as such.[34] But this understanding is historical, which is to say that this traumatic breakdown is historical, and no one evokes its effects quite like Warhol. "It's just like taking the outside and putting it on the inside," he once said of pop in general, "or taking the inside and putting it on the outside."[35] This is cryptic, but it does suggest a new relay between private fantasy and public reality as both an object and an operation in pop. "In the past we have always assumed that the external world around us has represented reality," J. G. Ballard, the best complement of Warhol in fiction, writes in an introduction to his great pop novel *Crash* (1973),

> and that the inner world of our minds, its dreams, hopes, ambitions, represented the realm of fantasy and the imagination. These roles, it seems to me, have been reversed. . . . Freud's classic distinction between the latent and manifest content of the dream, between the apparent and the real, now needs to be applied to the external world of so-called reality.[36]

The result of this confusion is a pathological public sphere, a strange new mass subjectivity, and it fascinated Warhol as it does Ballard.[37] I want to turn to this fascination because it does much to illuminate not only "death in America" but politics in America as well. To do so, however, a quick detour through political theory is necessary.

In his classic study *The King's Two Bodies* (1957), the historian Ernst Kantorowicz provides an anatomy of the body politic in the feudal order. On the one hand, the king represents this body politic (as in the synecdoche "I am England"), and on the other hand, he serves as its head; and in this corporal metaphor lies a measure of social hierarchy and political control. (A late imaging of this body politic appears as the famous frontispiece of the 1651 *Leviathan* of Hobbes.) However, with the bourgeois revolution, this image, this social imaginary, is threatened. As democracy decapitates the king, it "disincorporates" the body politic as well, and the result is a crisis in political representation. How can this new inchoate mass be represented?[38] For the political theorist Claude Lefort, totalitarianism is

a belated response to this crisis: the figure of the supreme leader returns as an "Egocrat" to reembody "the People-as-One."[39] But this return of the sovereign figure has a correlative in spectacular societies of the West: the politician as celebrity, the celebrity as politician, who rules through a politics of identification-as-projection—a return that Jürgen Habermas has called a "refeudalizing" of the public sphere.[40] In a gloss both on Habermas on the public sphere and on Lefort on democratic disincorporation, the critic Michael Warner describes this reembodiment in these terms: "Where printed public discourse formerly relied on a rhetoric of abstract disembodiment, visual media—including print—now display bodies for a range of purposes: admiration, identification, appropriation, scandal, and so forth. To be public in the West means to have an iconicity, and this is true equally of Muammar Qaddafi and Karen Carpenter."[41]

Again, Warhol was fascinated by this mass subject. "I want everybody to think alike," he said in 1963. "Russia is doing it under government. It's happening here all by itself."[42] Warhol was no situationist, but in his own blankly affirmative way he does register here a convergence between the "concentrated" spectacle of the Soviet Union and the "diffuse" spectacle of the United States, one that Debord foresaw in *Society of the Spectacle* (1967) and confirmed in *Comments on the Society of the Spectacle* (1988). And with his *Maos,* made in 1972 at the point of the Nixon opening to China, Warhol does suggest a related convergence of spectacular orders.[43] In any case, he was concerned to address the mass subject. "I don't think art should be only for the select few," Warhol commented in 1967. "I think it should be for the mass of American people."[44] But how does one go about such a representation in a society of consumer capitalism?

One way at least to evoke the mass subject is through its proxies, that is, through its objects of taste (thus the wallpaper kitsch of the flowers in 1964 and the folk logo of the cows in 1966) and/or its objects of consumption (thus the serial presentation of the Campbells and the Cokes, the Heinzes and the Brillos, from 1962 on).[45] But can one *figure* this subject? Does it have a body to figure? Or is it displaced in the fetishism of the commodity sign, dissolved in the society of the spectacle? "The mass subject cannot have a body," Warner asserts, "except the body it witnesses."[46] If we grant this principle provisionally, it may suggest why Warhol evokes the mass subject through its figural projections—from celebrities and politicians like Marilyn and Mao to all the lurid cover people of *Interview* magazine. It may also suggest why the world of Warhol was overrun by voyeurs and exhibitionists. For Warhol not only evoked the mass subject,

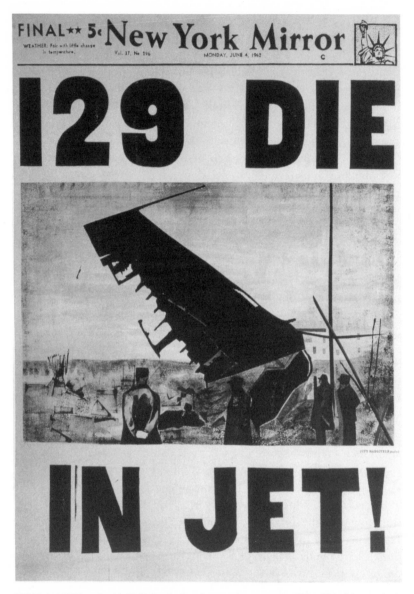

129 Die in Jet! (Plane Crash), 1962. Synthetic polymer paint on canvas, 100 × 72 in. Museum Ludwig, Cologne.

he also incarnated it; and he incarnated it precisely in its guise as "witness." This witnessing is not neutral or impassive; it is an erotics that is both voyeuristic and exhibitionist, both sadistic and masochistic, and it is especially active in two areas, the Factory filmmaking and the Warholian cult of celebrity. Here again Ballard is the best complement of Warhol, for while Ballard tends to explore the sadistic side of mass witnessing (his "Plan for the Assassination of Jacqueline Kennedy" [1966] and "Why I Want to Fuck Ronald Reagan" [1967] are classics of the genre), Warhol tends to slip into its masochistic side (as in his servility before the likes of Imelda Marcos and Nancy Reagan).[47]

However, Warhol did more than evoke the mass subject through its kitsch, commodities, and celebrities. He also represented it in its very unrepresentability, that is, in its absence and anonymity, its disaster and death. Eventually this led him to the *Skulls* (1976), the most economical image of the mass subject, for, as his assistant Ronnie Cutrone once remarked, to paint a skull is to do "the portrait of everybody in the world."[48] Yet Warhol had been drawn to death, the democratic leveler of famous mass object and anonymous mass subject alike, long before. Here is one more statement from the 1963 interview:

I guess it was the big crash picture, the front page of a newspaper: 129 DIE. I was also painting the *Marilyns*. I realized that everything I was doing must have been Death. It was Christmas or Labor Day—a holiday—and every time you turned on the radio they said something like, "4 million are going to die." That started it.[49]

But started what exactly? Nine years later Warhol returned to this question:

Actually you know it wasn't the idea of accidents and things like that. . . . I thought of all the people who worked on the pyramids and . . . I just always sort of wondered whatever happened to them . . . well it would be easier to do a painting of people who died in car crashes because sometimes you know, you never know who they are.[50]

This implies that his primary concern was not disaster and death but the mass subject, here in the guise of the anonymous victims of history, from the drones of the pyramids to the statistical DOAs at the hospitals.[51] Yet dis-

aster and death were necessary to evoke this subject, for in a spectacular so-
ciety the mass subject often appears as an *effect* of the mass media (the news-
paper, the radio), or of a catastrophic failure of technology (the plane
crash), or more precisely of both (the *news* of such a catastrophic failure).
Along with icons of celebrity like the *Marilyns* or the *Maos,* reports of dis-
astrous death like "129 Die" is a primary way that mass subjectivity is
made.[52]

Now even as the mass subject may worship an idol only to gloat over
his or her fall, so too it may mourn the dead in a disaster only to be warmed
by the bonfire of these bodies. In "The Storyteller" (1936), Benjamin sug-
gests that this is one service performed by the novel—to stir anonymous
readers with a singular death—and I want, through Warhol, to suggest that
media news offers a contemporary version of this mass warming.[53] Here,
again, in its guise as witness, the mass subject reveals its sadomasochistic as-
pect, for this subject is often split in relation to a disaster: even as he or she
may mourn the victims, even identify with them masochistically, he or she
may also be thrilled, sadistically, that there *are* victims of whom he or she
is *not* one. (There is a triumphalism of the survivor that the trauma of the
witness does not cancel out.)[54] Paradoxically, perhaps, this sadomasochistic
aspect helps the mass subject cohere as a collectivity. For the death of the
old body politic did not only issue in the return of the total leader or the
rise of the spectacular star; it also led to the birth of *the psychic nation,* that
is, to a mass-mediated polis that is not only convoked around calamitous
events (like the Rodney King beating or the Oklahoma City bombing)
but also addressed, polled, and reported as a traumatic subject (the gener-
ations that share the JFK assassination, the Vietnam War, and so on).[55]
Warhol was interested in this strange avatar of the mass subject; it is a shame
he did not live to see the golden age of hysterical talk shows and lurid mur-
der trials.

For the most part, Warhol evoked the mass subject in two opposite
ways: through iconic celebrity and abstract anonymity.[56] But he came clos-
est to this subject through a compromise representation somewhere be-
tween celebrity and anonymity, that is, through the figure of *notoriety,* the
fame of fifteen minutes. For me, his best representation of the mass subject
is an implicit double portrait: the most wanted man and the empty elec-
tric chair, the first a kind of modern icon, the second a kind of modern
crucifix.[57] What more exact representation of the pathological public
sphere than this twinning of iconic mass murderer and abstract state exe-
cution? That is, what more difficult image? When Warhol made his *Thir-*

teen Most Wanted Men for the 1964 World's Fair in New York, the people in power—men like Robert Moses and Philip Johnson, who not only designed the society of the spectacle but also represented it as the fulfillment of the American dream of success and self-rule—could not tolerate it.[58] As is well known, Warhol was ordered to cover up the image (which he did with his signature silver paint), and Moses was not amused when Warhol offered to substitute a portrait of Moses.

In a sense, the notoriety of the most wanted man is not so different from the notoriety of Warhol. For, again, he not only incarnated the mass subject as witness; he also instantiated the mass object as icon. This double status allowed Warhol to mediate between the two as well as he did; but it also suspended him between the iconicity of celebrity and the abstraction of anonymity. Perhaps it was this in-between position that made for his strange presence, at once very marked, even targeted (he was an easy celebrity to spot, a trait that advertisers came to exploit), and very white, even spectral (he was never *quite* there when he was *just* there on the street). Warhol emanated a flat uncanniness—as if he were his own double, his own stand-in.[59] As both witness and icon, voyeur and exhibitionist, he often seemed caught in a crossfire of gazes, which is to say that he too became an object of the sadomasochism of the mass subject. "In the figures of Elvis, Liz, Michael, Oprah, Geraldo, Brando, and the like," Warner writes, "we witness and transact the bloating, slimming, wounding, and general humiliation of the public body. The bodies of these public figures are prostheses for our own mutant desirability."[60] Even as he represented these figures, Warhol became one of them—a status that he both wanted desperately and refused quasi-autistically (no prosthesis of desirability he).

Perhaps, finally, it was this status as a star that set him up to be shot. For stars are products of our own light projected above us, and often we come to feel that they influence us (etymologically: flow into us) too much. As Warhol must have sensed, this star production can pass beyond the sadomasochistic to the paranoid: the relation to the star becomes a problem of distance (the star is too far from us, or too close) that is a problem of control (the star has too little, or too much, over us). Sometimes this conflict is only ended with the fall of the star; once in a while, the mass subject is driven to shoot the star down—to eject this ideal double from the blinded self. Such, it seems, was the case with Mark David Chapman vis-à-vis John Lennon in December 1980. Perhaps a similar imperative drove Valerie Solanis, a frustrated hanger-on of the Factory, to shoot Warhol in June 1968.

In lieu of a conclusion, I will end where I began, with the *The Philosophy of Andy Warhol*. This final monologue touches on most of my concerns here: a traumatic notion of the real, a contemporary version of the optical unconscious, a historical confusion between private fantasy and public reality, a hysterical relay between mass subject and mass object, a forging of a psychic nation through mass-mediated disaster and death:[61]

> Before I was shot, I always thought that I was more half-there than all-there—I always suspected that I was watching TV instead of living life. People sometimes say the way things happen in movies is unreal, but actually it's the way things happen to you in life that's unreal. The movies make emotions look so strong and real, whereas when things really do happen to you, it's like watching television—you don't feel anything.
>
> Right when I was being shot and ever since, I knew that I was watching television. The channels switch, but it's all television. When you're really involved with something, you're usually thinking about something else. When something's happening, you fantasize about other things. When I woke up somewhere—I didn't know it was at the hospital and that Bobby Kennedy had been shot the day after I was—I heard fantasy words about thousands of people being in St. Patrick's Cathedral praying and carrying on, and then I heard the word "Kennedy" and that brought me back to the television world again because then I realized, well, here I was, in pain.

Notes

1. Andy Warhol, *The Philosophy of Andy Warhol* (New York: Harcourt Brace Jovanovich, 1975), p. 123. This text began as a talk at a conference convened at the Andy Warhol Museum by Colin MacCabe, Mark Francis, and Peter Wollen in April 1995. I also thank participants in the Visual Culture Colloquium at Cornell University, in particular Susan Buck-Morss, Geoff Waite, and especially Mark Seltzer. Finally, I dedicate the text to the memory of Bill Readings, a true critical theorist who possessed a terrific *joie de vivre*.

2. "Death in America" was the title of a projected show in Paris of "the electric-chair pictures and the dogs in Birmingham and car wrecks and some suicide pictures." Gene Swenson, "What Is Pop Art? Answers from Eight Painters, Part I," *Art News* 62 (November 1963): 26.

3. My way to this notion has come through the artwork of Sarah Pierce. I think it opens onto other realisms not only after the war (photorealist and appropriation art in particular) but before as well (surrealism in particular)—a genealogy that I sketch in "Reality Bites," in Virginia Rutledge, ed., *Hidden in Plain Sight: Illusion and the Real in Recent Art* (Los Angeles: Los Angeles County Museum of Art, 1996). I am also interested in this notion as one way to think beyond the stalemated oppositions of new art history—semiotic versus social-

historical, text versus context—as well as of cultural criticism—signifier versus referent, constructivist subject versus naturalist body.

4. Roland Barthes, "That Old Thing, Art," in Paul Taylor, ed., *Post-Pop* (Cambridge: MIT Press, 1989), p. 25.

5. Ibid., p. 26.

6. Jean Baudrillard, "Pop—An Art of Consumption?" in Taylor, ed., *Post-Pop,* p. 33. (This text is extracted from *La société de consommation: ses mythes, ses structures* [Paris: Gallimard, 1970], pp. 174–185.)

7. Ibid., p. 35. Neither position is wrong, I will argue throughout this text; rather, the two must be thought somehow together.

8. Thomas Crow, "Saturday Disasters: Trace and Reference in Early Warhol," reprinted in this volume, pp. 51, 55. Crow's essay appeared in earlier form in *Art in America* (May 1987) and in Serge Guilbaut, ed., *Reconstructing Modernism* (Cambridge: MIT Press, 1990).

9. Ibid., in this volume, p. 58.

10. Ibid., pp. 58, 60. Again, his "attraction" to these subjects may not be "complacent," but it is not necessarily critical.

11. Gretchen Berg, "Andy: My True Story," *Los Angeles Free Press,* March 17, 1963, 3. Warhol continues: "I see everything that way, the surface of things, a kind of mental Braille, I just pass my hands over the surface of things. . . . There was no profound reason for doing a death series, no victims of their time; there was no reason for doing it at all, just a surface reason." Of course, this very insistence could be read as a denial, that is, as a signal that there may be a "profound reason." This shuttling between surface and depth may be unstoppable in pop; indeed, it may be characteristic of (its) traumatic realism.

12. This is not to say that there are no qualitative differences between projections, or between fascinated projections and motivated interpretations.

13. Swenson, "What Is Pop Art?" p. 26.

14. Ibid.

15. I hesitate between "product" and "image" and "make" and "consume" because, historically, Warhol seems to occupy a liminal position between the orders of production and consumption; at least the two operations appear blurred in his work. This liminal position might also bear on my hesitation between "shock," a discourse that develops around accidents in industrial production, and "trauma," a discourse in which shock is rethought in the register not only of psychic causality but also of imaginary fantasy—and so, perhaps, a discourse that is more pertinent to a consumerist subject.

16. Indeed, artists like Jeff Koons have run it right into the ground. For this capitalist nihilism in Dada, see my "Armor Fou," *October* 56 (Spring 1991); and in Warhol, see Benjamin Buchloh, "The Andy Warhol Line," in Gary Garrels, ed., *The Work of Andy Warhol* (Seattle: Bay Press, 1989). In Dada, in much reactionary representation of the 1920s, and again in contemporary art, this nihilism assumes an infantilist aspect, as if "acting out" were the same as "performing."

17. Undated statement by Warhol, as read by Nicholas Love at the memorial Mass for Andy Warhol, St. Patrick's Cathedral, New York, April 1, 1987, and as cited in Kynaston McShine, ed., *Andy Warhol: A Retrospective* (New York: Museum of Modern Art, 1989), p. 457.

18. Andy Warhol and Pat Hackett, *POPism: The Warhol '60s* (New York: Harcourt Brace Jovanovich, 1980), p. 50.

19. Swenson, "What Is Pop Art?" p. 60. That is, it still has an effect, but not really. I mean my use of "affect" not to reinstate a referential experience but, on the contrary, to suggest an experience that cannot be located precisely.

20. But this is the role of art history in relation to Warhol (among many others): to find a referent, to develop an iconography, in order to integrate the work. In some ways Warhol defies this process, as did Rauschenberg before him; in other ways they both play right into it.

21. Sigmund Freud, "Mourning and Melancholia" (1917), in Freud, *General Psychological Theory,* ed. Philip Rieff (New York: Collier Books, 1963), p. 166. Crow is especially good on the Warhol memorial to Marilyn, but he reads it in terms of mourning more than of melancholia.

22. See Jacques Lacan, *The Four Fundamental Concepts of Psychoanalysis,* trans. Alan Sheridan (New York: W. W. Norton, 1978), pp. 17–64. The seminar that follows, "Of the Gaze as Objet Petit a," has received more attention, but this seminar has as much relevance to contemporary art (in any case, the two must be read together). For a provocative application of the seminar on the real to contemporary writing (including Ballard), see Susan Stewart, "Coda: Reverse Trompe l'Oeil\The Eruption of the Real," in her *Crimes of Writing* (New York: Oxford University Press, 1991), pp. 273–290.

23. Lacan, *Four Fundamental Concepts,* p. 50.

24. "I am trying here to grasp how the *tuché* is represented in visual apprehension," Lacan states. "I shall show that it is at the level that I call the stain that the tychic point in the scopic function is found" (ibid., p. 77). This tychic point, then, is not in the world but in the subject, but in the subject as an effect, a shadow or a "stain" cast by the gaze of the world. Lacan argued that this gaze "qua *objet a* may come to symbolize this central lack expressed in the phenomenon of castration" (ibid., p. 77). In other words, the gaze queries us about our rupture.

25. Roland Barthes, *Camera Lucida,* trans. Richard Howard (New York: Hill and Wang, 1981), pp. 26, 55, 53. For an account of this connection between Barthes and Lacan, see Margaret Iversen, "What Is a Photograph?" *Art History* 17, no. 3 (September 1994): 450–464.

26. Yet another instance of this popping is the blanking of the image (which often occurs in the diptychs, for example in the black panel opposite the panel of the crashes in *Five Deaths Seventeen Times in Black and White* [1963]). This blanking works as a kind of correlative of a blackout or a blank-down in shock. (For the point about the blur in Richter, I am indebted to the art and music critic Julian Meyers.)

27. Lacan, *Four Fundamental Concepts,* p. 54.

28. For that matter, it is a great subject of modernism from Baudelaire to surrealism and beyond. See, of course, Walter Benjamin, "On Some Motifs in Baudelaire" (1939), in Benjamin, *Illuminations,* trans. Harry Zohn (New York: Schocken Books, 1969). Also see Wolfgang Schivelbusch, *The Railway Journey* (Berkeley: University of California Press, 1986).

29. In fact, the notion is not much developed by Benjamin. See the passing references in "A Short History of Photography" (1931), in Alan Trachtenberg, ed., *Classic Essays on Photography* (New Haven: Leete's Island Books, 1980), and "The Work of Art in the Age of Mechanical Reproduction" (1936) in Benjamin, *Illuminations.*

30. These shocks may exist in the world, but they occur in the subject. Certainly they develop as traumas only in the subject. And to develop in this way, to be registered as a trauma, requires that the first event, the shock, be recoded by a later event (this is what Freud meant by the deferred [*nachträglich*] action at work in trauma: it takes two traumas to make a

trauma). This distinction is important for my reading of Warhol, especially in the next section, for what is first a calamity, like the JFK assassination, or a disaster, like the *Challenger* explosion, only becomes a trauma later, *après-coup;* and the mass subjectivities effected by shock and trauma are different.

31. In "Information, Crisis, Catastrophe," Mary Anne Doane argues that television coverage serves to block the shock of catastrophic events, only to produce this effect when its coverage fails (in Patricia Mellencamp, ed., *Logics of Television* [Bloomington: Indiana University Press, 1990]). As suggested, the Warhol washing of the image in color often screens and reveals the traumatic real in a similar way. These washes might then recall the hysterical red that Marnie sees in the eponymous film by Hitchcock (1964). But this red is too coded, almost safely symbolic, even iconographic. The Warhol colors are more acrid, arbitrary, effective.

32. Warhol, *The Philosophy of Andy Warhol,* p. 81. In "Andy Warhol's One-Dimensional Art: 1956–1966," Benjamin Buchloh argues that "consumers . . . can celebrate in Warhol's work their proper status of having been erased as subjects" (reprinted in this volume, p. 37). This is the other extreme of the position argued by Crow that Warhol exposes "complacent consumption." Again, rather than choose between the two, we must somehow think them together.

33. I discuss this genealogy in *The Return of the Real* (Cambridge: MIT Press, 1996).

34. I repeat this point because with artists like Warhol and Richter the *punctum* is not strictly private or public. This is especially the case with the Richter suite of paintings titled *October 18, 1977* (1988) concerning the deaths in the Baader-Meinhof group. The painting of the little record player kept by Andreas Baader holds a special charge for me. This is not a private affair, and yet I cannot explain it through any public studium—its use in prison, its status as an outmoded leisure commodity, whatever. I am aware of the psychologistic tendency of this section of my text, in particular the slippage of trauma from a psychoanalytic definition to a sociological application, but I think my subject requires it.

35. Berg, "Andy: My True Story," p. 3.

36. This introduction appears in the French translation of *Crash* (Paris: Calmann-Levy, 1974); it was published in the original English in *Foundation* 9 (November 1975) and in *Re/Search* 8/9 (1984; J. G. Ballard issue), p. 98. In this regard, Warhol and Ballard point to an important concern in recent psychoanalytical art and criticism (e.g., the work of Slavoj Žižek): the role of fantasy in the social imaginary and the body politic.

37. Mark Seltzer develops the notion of a pathological public sphere in "Serial Killers II," *Critical Inquiry* (Fall 1995).

38. This is a primary question for many modernists, mainly socialists, across a range of practices (e.g., Sergei Eisenstein, El Lissitzky, John Heartfield, Diego Rivera), but Warhol addresses it, too, from his own perspective. In *Crowd* (1963), for example, the mass appears as a truncated blur of a newspaper photo or a television image barely seen or remembered. In crowd theory of the nineteenth century, most of which is quite reactionary (e.g., Gustave Le Bon), the problem is posed explicitly in terms of control: how to restrain the mass in representation. (I am grateful to Susan Buck-Morss for her attention to this neglected part of the modernist project.)

39. Claude Lefort, "The Image of the Body and Totalitarianism," in John B. Thompson, ed., *The Political Forms of Modern Society* (Cambridge: MIT Press, 1986), pp. 298–299. For the image of the body in Italian fascism, see Jeffrey Schnapp, *Staging Fascism* (Palo Alto: Stanford University Press, 1995).

40. Jürgen Habermas, *The Structural Transformation of the Public Sphere,* trans. Thomas Burger (Cambridge: MIT Press, 1989), p. 201. First published in 1964, this landmark text is also roughly contemporaneous with the *Death in America* images.

41. Michael Warner, "The Mass Public and the Mass Subject," in Bruce Robbins, ed., *The Phantom Public Sphere* (Minneapolis: University of Minnesota Press, 1993), p. 242. My line of argument here is indebted to Warner, who also discusses Ballard.

42. Swenson, "What Is Pop Art?" p. 26.

43. For an extraordinary meditation on different mass subjectivities from Chairman Mao to Doctor Moon, from the novel to terrorism in the news, see Don DeLillo, *Mao II* (New York: Viking, 1991).

44. Berg, "Andy: My True Story," p. 3. He also preferred the term "commonist" to "pop."

45. *The Philosophy of Andy Warhol* includes an ode to Coke that celebrates the absurd democracy of consumerism at issue here: "What's great about this country is that America started the tradition where the richest consumers buy essentially the same things as the poorest. You can be watching TV and see Coca-Cola, and you can know that the President drinks Coke, Liz Taylor drinks Coke, and just think, you can drink Coke, too. A Coke is a Coke and no amount of money can get you a better Coke than the one the bum on the corner is drinking. All the Cokes are the same and all the Cokes are good. Liz Taylor knows it, the President knows it, the bum knows it, and you know it" (pp. 100–101). In this ad for democracy there is only one Real Thing, and We are indeed the World.

46. Warner, "The Mass Public," p. 250.

47. This is where the principle "the mass subject cannot have a body except the body it witnesses" might be qualified. For the mass does "have" a body (as with the phallus, having and being a body are not the same): it has a body in the sense that it may be convoked not only through a body (e.g., a celebrity) but as a body (e.g., a collective shocked or traumatized by the same event). It also retains its bodies in the usual sense (mass subjects as "organisms" rather than as "spectators" in the terms of my Ballard epigraph). These individual bodies of desires, fears, and fantasies allow mass subjects to customize mass objects in personal and/or group ways (e.g., gay, Catholic, working-class); in the case of Warhol, to camp or to clone images of Elvis, Troy, Warren, Marlon, and other most wanted men in terms of gay desire (on this point, see Richard Meyer, "Warhol's Clones," *Yale Journal of Criticism* 7, no. 1 [1994]). To use a notion like "mass subject," then, is not necessarily to massify the subject, to disallow personal and/or group appropriations. In fact, the Factory was a virtual factory of such reinventions. For another analysis of some of these problems, see Christopher Phillips, "Desiring Machines," in Gary Garrels, ed., *Public Information: Desire, Disaster, Document* (San Francisco: Museum of Modern Art, 1995). (The two Ballard texts are collected in *The Atrocity Exhibition* [London: Jonathan Cape, 1969].)

48. Ronnie Cutrone quoted in Trevor Fairbrother, "Skulls," in Garrels, ed., *The Work of Andy Warhol,* p. 96. This is the best text I know on the theme of death in Warhol.

49. Swenson, "What Is Pop Art?" p. 60. It is at this point that Warhol remarks, "But when you see a gruesome picture over and over again, it doesn't really have any effect." And yet this particular image from 1962 is not repeated, and with the blackened wing become a deathly scythe, Warhol heightens its grim fatality.

50. David Bailey, *Andy Warhol: Transcript* (London, 1972), quoted by Buchloh in "Andy Warhol's One-Dimensional Art," p. 27. Here, perhaps, there is a point of contact, however inadvertent, with Brecht; see, for example, his poem "The Worker Reads History."

51. Warhol captures the catastrophic version of contemporary death, in which "death is no longer the culminating experience of a life rich in continuity and meaning but, instead, pure discontinuity, disruption—pure chance or accident, the result of being in the wrong place at the wrong time." Doane, "Information, Crisis, Catastrophe," p. 233.

52. "Disaster is popular, as it were," Warner writes, "because it is a way of making mass subjectivity available, and it tells us something about the desirability of that mass subject" ("The Mass Public," p. 248). What are the different effects of the different mediations (newspaper, radio, network television, satellite and cable news, Internet) of modern disaster? For example, what is the difference in subject-effect between readings of the *Titanic* sinking and viewings of the *Challenger* exploding? Is the first as given over to compulsive repetitions, to the jouissance of the death drive, as the second?

53. "What draws the reader to the novel," Benjamin writes, "is the hope of warming his shivering life with a death he reads about" (*Illuminations*, p. 101).

54. This point may bear on the guilty implication that a mass subject may feel in relation to a disaster—that he or she has somehow participated in it, even indirectly caused it, as a spectator. Sometimes a disaster prompts a confusion of cause and effect, let alone of public and private, that is difficult to register except as a reversal, in which the subject—paranoiacally and pathetically—feels that he or she has dictated the event, or at least colluded in its fixing. Consider the superstitions of sports fans, who gyrate in front of televisions so that a catch be made, a putt sunk, or who turn off the game lest the hero fail, the team lose. (I am indebted to Christopher Pye for this example of reversal.)

55. Again, the difference is this: a shock may be instantaneous; a trauma takes time to produce (see note 30). This convoking of a mass subject through shock may be easier to register at the level of the city. To be a witness in New York in the 1980s, for example, was to lurch from one fatal event to another (from Lisa Steinberg to Jennifer Levin, say, from Howard Beach to Bensonhurst), events usually marked by extreme violations of difference—generational, sexual, and/or ethnic. These events wired New Yorkers, shocked them into a collectivity of (dis)identification, which is a role that New York long played for the rest of the psychic nation. This part has now passed in part to Los Angeles, the city that, outside of Hollywood Babylon, was long imagined to be free of such events.

The term "psychic nation" may be too slippery to define, let alone to locate. The "psychification" of the nation is an old tendency in cultural criticism, from the "nervous" 1880s to the "narcissistic" 1970s and the "schizophrenic" 1980s. I do not intend an analogy, much less an equivalence, between psyche and nation. Rather I see the presumed commutability of the two as another symptom of a breakdown between private and public (which is also difficult to define, let alone to locate). There is also the question of the technological mediation of the psychic nation: again, how does this kind of collectivity change with different media? And when does it exceed the national as a matter of course? This question may point to a difference between the early 1960s and the middle 1990s. In an almost sociological way, Warhol could use certain images to represent "death in America" for a show in Paris, with the assumptions that these images would not be known there and that American types of death were somehow distinctive. Today images of the carnage of the Oklahoma City bombing (or, for that matter, of the Sarajevo shelling) are broadcast internationally: the nation is hardly a boundary of the psychic collectivity effected by disaster and death. Indeed, not long after the early 1960s, "death in America" might just as well signal death in Vietnam. Perhaps it was then, with the television reportage of the war, that the national boundary was definitively transgressed. In any case, it is significant that Warhol tended to steer clear of these war images and indeed of television images.

56. These are opposite but not opposed, for most celebrities are so constructed in the social as to appear characterless if not anonymous.

57. Traces of churchly art are everywhere in Warhol: the gold relics of the shoe ads, the shrines to Marilyn and others, the Vanitas skulls, the patron portraits, and so on. (I am indebted to Peter Wollen for the association of electric chair and crucifix.)

58. Even though these criminals fulfill this dream too, equal (if opposite) to any other top ten (or thirteen) list: the richest, the best dressed, and so on. On this point, see Sidra Stich, "The American Dream/The American Dilemma," in *Made in USA: An Americanization in Modern Art, the '50s and '60s* (Berkeley: University of California Press, 1987), p. 177.

59. "Pop art rediscovers the theme of the Double . . . but [it] is harmless—has lost all maleficent or moral power . . . the Double is a Copy, not a Shadow: beside, not behind: a flat, insignificant, hence irreligious Double." Barthes, "That Old Thing, Art," p. 24. Perhaps any encounter with a celebrity produces a degree of this flat uncanniness.

60. Warner, "The Mass Public," p. 250.

61. This statement appears on p. 91 of *The Philosophy of Andy Warhol*. It also touches on a few related concerns that I have not much developed here: the dialectic of media and technology as both shock and shield for the subject, the complication in trauma of causality and temporality, the irreducibility of the body in pain. As for the first point, also see this statement in *The Philosophy*: "The acquisition of my tape recorder really finished whatever emotional life I might have had, but I was glad to see it go. . . . During the '60s, I think, people forgot what emotions were supposed to be. And I don't think they've ever remembered. I think that once you see emotions from a certain angle you can never think of them as real again. That's what more or less has happened to me" (pp. 26–27).

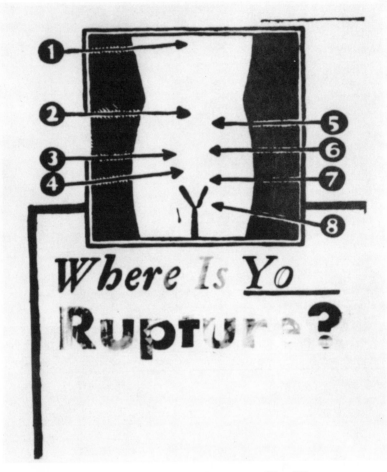

Where Is Your Rupture?, 1960. Synthetic polymer paint on canvas, 69¾ × 54 in.

"Where Is Your Rupture?"
Mass Culture and the *Gesamtkunstwerk*

Annette Michelson

And if the body were not the soul, what is the soul?

Walt Whitman

A specter haunts the theory and practice of the arts throughout our century: the specter of the *Gesamtkunstwerk*, a notion born of late romanticism, nurtured and matured within the modernist moment, and never wholly exorcised in the era of postmodernism and electronic reproduction. To Adorno, writing in 1944, television promised a synthesis of radio and film which would so impoverish artistic production that "the thinly veiled identity of all industrial products" would reveal itself,

> derisively fulfilling the Wagnerian dream of the *Gesamtkunstwerk*—the fusion of all the arts in one work. The alliance of word, image, and music is all the more perfect in *Tristan* because the sensuous elements which all approvingly reflect the surface of social reality are in principle embodied in the same technical process, the unity of which becomes its distinctive content. This process integrates all the elements of the production, from novel (shaped with an eye to film) to the last sound effect. It is the triumph of invested capital, whose title as absolute master is etched deep into the hearts of the dispossessed in the employment line; it is the meaningful content of every film, whatever plot the production team may have selected.[1]

To the specter of the *Gesamtkunstwerk*, already somewhat faint and failing, Moholy-Nagy had delivered, in 1925, a telling, though not fatal, blow. In *Painting, Photography, Film*,[2] he says, speaking of the project of cubism and constructivism, that they attempted a purification of the expressive com-

ponent of "art" (one notes the quotation marks), that they led an attack
upon the subjectivism of a previous generation, whose relegation of art to
preoccupations of leisure-time activity went hand in hand with an exces-
sively sublimated notion of artistic production, issuing in an art that was
trivial and derivative, severed from its roots in social collectivity. He then
evokes, as a second line of protest, "the attempt to bring together into one
entity, singular works or separate fields of creation that were isolated from
one another. This entity was to be the *Gesamtkunstwerk* in the form of ar-
chitecture as the sum of all arts." Such was the project of De Stijl and of
the Bauhaus in its first period.[3] But this project Moholy defines as pro-
duced within a specific historical moment, that of the triumph of special-
ization. And this we retrospectively understand as the consequence of the
division of labor as the dynamic of the industrial revolution. It is with char-
acteristic acuteness that Moholy perceives this ideal as a compensatory re-
action to a general fragmentation of existence and therefore incapable of
providing the ground for an art of social collectivity, an art of necessity.

For it provides, as it were, merely an addition to the present state of
things, an increment. "What we need," he says, "is not the *Gesamtkunstwerk*
alongside and separate from which life flows by, but a synthesis of all the
vital impulses spontaneously forming itself into the all embracing
Gesamtwerk (life) which abolishes all isolation, in which all individual ac-
complishments proceed from a biological necessity and culminate in a
universal necessity."[4]

There would seem to have been two major, antithetical programs for
the achievement of this radically utopian aesthetic in our century. One
might call them, roughly speaking, those of the Yogi and the Commissar,
casting Moholy as Commissar and recasting (with the respect and apolo-
gies due a Zen master) John Cage as the Yogi. I wish, however, to consider
a third attempt of the recent past, one whose deviant logic was preemi-
nently of our time, producing a mediate or degraded version of this proj-
ect. I have in mind a site of artistic production perspicuously exempt, if
only for a brief period of time, from industrial criteria of production,
modes of distribution, and commodification. It was, as it happens, a film
studio. I shall not, however, be proposing, in the manner of Moholy's con-
temporaries, the cinema as the ultimate *Gesamtkunstwerk*. Rather, I shall
consider the structure and dynamics of this site of production as a late vari-
ant upon Moholy's model, subject, however, to the powerful constraints
and perversions of its particular moment within late capitalism.

The site and period, then, are those of Andy Warhol's old Factory, described by Warhol himself as those in which "we made movies just to make them" rather than that period in which he was producing "feature-length movies that regular theaters would want to show." The shot from Valerie Solanis's gun in 1968 marks the boundary between two sites and modes of production, the moment when a systematic division of labor replaces a previous artisanal mode of production. When, as has been noted, Warhol began increasingly to delegate authority, as in the later films, his participation was limited to the work of finance and publicity. *The Chelsea Girls* is the major work that concludes the first period. After 1968, Warhol assumed the role and function of the *grand couturier*, whose signature sells or licenses perfumes, stockings, household linens manufactured elsewhere.[5] Warhol's "business art" found its apogee in the creation of a label that could be affixed to the feature films made under the direction of Paul Morrissey. And Morrissey's role in the suppression of films made prior to his accession to power is linked to the marketing of the new product, coded with an eye to industrial norms.

Consider, then, the image that provides the title of this text. Dated 1960, numbered 83 in the catalogue of the 1989 Museum of Modern Art retrospective exhibition, it is, of course, the rendering of an advertisement for surgical trusses, an early instance of Warhol's deployment of the found image; he was to rework it more than once. It is, as well, an image of poignantly proleptic resonance, and we may therefore quite appropriately juxtapose it with *Andy Warhol, Artist, New York City*, Richard Avedon's portrait, made in 1969, in which the artist displays the surgical scars that memorialize the assault upon his life made the preceding year by Valerie Solanis, executor-in-chief of the Society to Cut Up Men.

In what follows, however, I shall be rehearsing neither the Orphic nor the hagiographic iconography that this juxtaposition may appear to generate. More significantly, these two images mark the limits of Warhol's intervention as a major and pivotal force within the America cinema of independent persuasion and production. And it is through that intervention that one may trace the passage, within that cinema, from the body's analytic representation to one of synthetic incorporation.

Most simply put, the notion of rupture will center on the break within the American cinema of independent production and persuasion in the representation of the body as effected by Warhol and its consequences: the passage from a cinema postulated on the primacy of the part

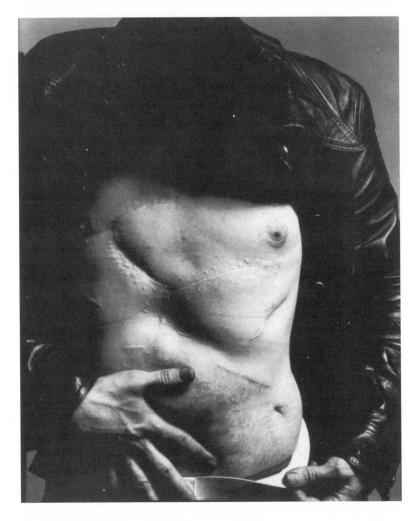

Richard Avedon, *Andy Warhol, Artist, New York City, 8/20/69.*

object to that of the whole object, in its parallel passage from one of assertive editing to that of long shot/*plan séquence*.[6] What later followed was the development of a cinema tending toward incorporeality, as in the work of Michael Snow and Hollis Frampton—to "the taste's quick glance of incorporeal sight," a cinema of literal textuality.

If it may be claimed that the desire for the mode of representation which came to be that of cinema is grounded in the phantasmatic projection of the female body,[7] we may see confirmation of that claim in a founding myth of cinematic practice, that of Kuleshovian montage. One of its powerfully constituent elements posits the desiring gaze of the male subject, directed at the female object as inferred, synthesized by, the spectator from the sequence of shots of the actor, Mosjoukine, and a presumably anonymous female. We have, however, an even more impressively demonstrative instance of cinema's synthetic properties, its construction of the female body, the ideal object of desire as synthesized, once again, by the viewer, as if inevitably, from the juxtaposition of part objects.

This founding moment is, however, inscribed within a tradition of Russian literature that extends from Gogol to Bely. Indeed, in Bely's *Petersburg* (1912), we find the following: "Alexander Ivanovich was thinking that features of Zoya Zacharovna's face had been taken from several beautiful women: the nose from one, the mouth from another, the ears from a third beauty. But all brought together, they were irritating."[8] In this passage, Bely anticipated, as well, the early spectator's uneasy reaction to assertive editing and the extreme close-up.

In the United States, a new era in the representation of the body begins in the period following the Second World War, with the early films of Maya Deren, to be sure, but perhaps more pertinently, for present purposes, in the work of collaboration between the filmmaker Willard Maas and the British poet George Barker, at that time resident in New York. *Geography of the Body,* produced, like *Meshes in the Afternoon,* in 1943, develops the grand metaphor of the body as landscape through the succession of extreme close-ups in which skin, fold, membrane, hair, limb, and member are transformed into plateaux, prairies, pools, caves, crags, and canyons of uncharted territory. The body, estranged, then does appear as an "America," a "Newfoundland," its lineaments suffused with the minatory thrill of exploration. This film text works, through close-up, magnification, and its editing patterns, to disarticulate, to reshape and transform, the body into landscape, thereby converging, in a manner that is both curious and inter-

esting, with that filmic microscopy which now offers us passage through the canals of the reproductive and cardiovascular systems.

It was the project of Stan Brakhage to chart this landscape, and—through hyperbolization of montage, radical suppression of the establishing shot, and systematic use of close-up—to expand, with a view to its cosmic extrapolations, the disarticulated body's analogical virtuality, as in *Prelude, Dog Star Man* (1964). And we can now clearly see that the trajectory initiated in *Window Water Baby Moving* (1958), the early masterwork produced in documentation of the birth of his first child, culminates in *The Act of Seeing with One's Own Eyes* (1974), filmed in the Pittsburgh morgue. Brakhage now offered the autopsist's literal, manual dismembering of the human cadaver: the cutting up of men and women.

I shall, however, want to claim that there is a dominant trend toward the representation of a body-in-pieces, of what is, in Kleinian theory, termed the part object, that runs, like an insistent thread, a sustained subtext, through much of American artistic production (and through its painting and sculpture, in particular) in the 1950s and 1960s. Art objects as part objects, then. Locating the sources, we encounter, once again, in a surprisingly wide range of work, the haunting seminal presence to whom artists of that period paid, in varying forms and degrees of intent, a steadily intensifying tribute: that of Marcel Duchamp. This effort of location entails consideration of a few works of emblematic import.

The first of these is *11, rue Larrey* (1927), that door which, in defiance of the apothegm, stands both open and closed, at one and the same time. Reflecting now, more than a quarter-century later, upon the old Factory, one recalls that site whose threshold was indeed marked by a door both open and closed: the space in which one could, as the saying goes, "swing both ways," where stern imperatives of choice, the strict polarity of either/or, reified in the austere ethos of abstract expressionism, were abrogated, displaced by what is currently termed "sexual preference." In this arena, whose ecumenicity accommodated homosexuality, heterosexuality, bisexuality, asexuality, *MARiée* and *CELibataire* were daily conjoined, and frequently within the prototypical single body, single persona.

Duchamp has offered us, however, in addition to this emblem of indifference, another set of images, representations of that supreme part object, the prime object of infantile identification and projection: the breast. *Prière de toucher* (1947) was to be followed by the sculptural renderings of the male and female sexual parts, *Feuille de vigne femelle* (1950) and *Objet-Dard* (1951). And we are, I shall want to claim, justified in seeing *Rotary Demi-*

Sphere (Precision Optics) (1925) as a prototype of *Anemic Cinema* (1927), which conflates, in its spirals' alternately receding and projecting movement, penis and breast—often identified by the infant as one and split off in impulses of rage and/or love. I refer, of course, to the theorization of the part object by Melanie Klein, as founded upon that of Karl Abraham in his attribution of the importance for the child of the relation to part objects such as the breast (or feces) in his work on melancholia. Klein later posits the initial introjection, by the child, of the mother's breast and a constant splitting of its good (giving) and bad (rejecting) aspects, aimed at introjection of a good breast and the projection and annihilation of a bad one. Moreover—and this will have bearing upon one's readings of Duchamp and of other artists whose work concerns us—the cannibalistic relation to the breast is, during the second oral stage, transferred to the penis as well; both are revealed, in significant case histories, as the objects of deepest oral desires. Klein was to go on to observe that the sadistic, cannibalistic fantasies and anxieties aggravated by weaning would lead the child to displace its interest onto the whole of the mother's body, so that a primitive Oedipal envy and jealousy is thereby added to the oral sadism. And a urethral and anal sadism, added to the oral, would lead to the stage described by Melanie Klein as the stage of maximum sadism:

> Every other vehicle of sadistic attack that the child employs, such as anal sadism and muscular sadism is in the first instance leveled against its mother's frustrating breast, but it is soon directed to the inside of her body, which thus becomes at once the target of every highly intensified and effective instrument of sadism. In early analysis, these anal-sadistic, destructive desires of the small child constantly alternate with desires to destroy its mother's body by devouring and wetting it, but their original aim of eating up and destroying her breast is always discernable in them.[9]

The Kleinian scenario of infantile development is, of course, that of a horror feature, the longest-running one known to us. Klein and Hanna Segal were to go on to elaborate upon the notion of children's art and art in general as involving the desire to repair and make restitution to the object of destructive fantasies.

Our best point of entry into the consideration of the role of the part object within the art of the mid-1950s through the 1960s is to be found in the work of Eva Hesse. This choice is dictated by the conviction that it

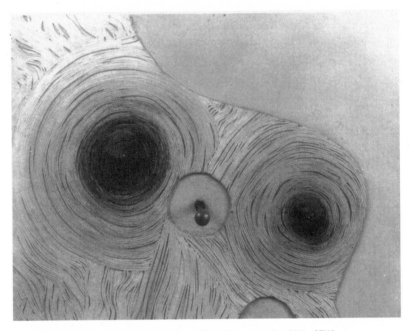

Eva Hesse, *2 in 1*, 1965. Cord, glue, paint, wooden ball on masonite, 21¼ × 27⅛ in.

was the major achievement of a woman artist to have made, through her obsessive constitution of a repertory of part objects (and this within the minimalist moment), the elements of a radical renewal of sculptural enterprise, of its grammar and its materials. It is this primal image, the archetypal part object, that is more generally inscribed within the broadest range of American artistic production of the late 1950s through the 1960s in forms and variations so diverse as almost to defy inventory. Its presence was, of course, effectively masked by the dominant critical and theoretical discourse of the period, even as it ranged from the work of Kenneth Noland to that of Jasper Johns. And in Johns's celebrated and enigmatic *Target with Plaster Casts* (1955), in addition to the part objects cast and placed in the upper-level compartments, we may discern in the image of the main panel more than a representation of "surface," of "flatness, itself."

It is therefore interesting to consider the reading of this work offered, in 1963, by Leo Steinberg, then engaged in a pioneering critique of the claims of "formalist" criticism. Remarking on the manner in which Johns's subjects tend to be "whole entities" or complete systems, seen from no particular angle, Steinberg infers a refusal to manifest subjectivity. He then remarks, however, upon *Target* (1955) of which Nicholas Calas had

written, "One-ness is killed either by repetition or fragmentation." Having described the inserted anatomical fragments and recorded Johns's explanation of their insertion as the casual adoption of readymades (they "happened" to be around in the studio), Steinberg then goes on to remark that "these anatomical parts are not whole," that "only so much of them is inserted as will fit in each box," that "they are clipped to size," and he concludes that "the human body is not the ostensible subject. The subject remains the bull's-eye in its wholeness, for which the anatomical fragments provide the emphatic foil."[10]

What then follows is the account of a verbal jousting between Steinberg and Johns, with Johns characteristically insisting on the absence of either overt or implicit emotional content, on his desire (as seen by Steinberg) to excise meaning from them.

But Steinberg is characteristically uncomfortable with this position, for "when affective human elements are conspicuously used, and yet not used as subjects, their subjugation becomes a subject that's got out of control. At any rate, no similar fracturing of known wholes has occurred since in Johns's work."[11] And "the assumption of a realism of absolute impersonality always does fail—if taken literally. That assumption is itself a way of feeling; it is the ascetic passion which sustains the youthful drive of a youthful Velasquez, or a Courbet while they shake the emotional slop from themselves and their models."[12]

Johns's contention, directed against Steinberg's reading of his paintings as works of absence, leaves Steinberg with a feeling of almost palpable dissatisfaction. He has certainly circled in closer to these elusive works, but he has not, as it were, quite grasped them. But hasn't he passed too rapidly over the central panel, that of the target, the bull's eye? For the target is surely another conventionalized variant of that primal object whose interest is, in this instance, heightened for us in that it is represented as the explicit object of aggression.

Bearing in mind this consideration of the part object, epitomized in a range of practices—in those, among others, of Duchamp, Johns, Noland, Hesse, and in the editing patterns of Brakhage, as inheritor of the "classical" or postrevolutionary tradition of montage—I return to consideration of the Factory, reentering through that swinging door. I do so however, by way of a detour.

There is a story—apocryphal perhaps—of Verlaine's impoverished last years, of the Paris garret and its meager furnishings, entirely covered in gilt

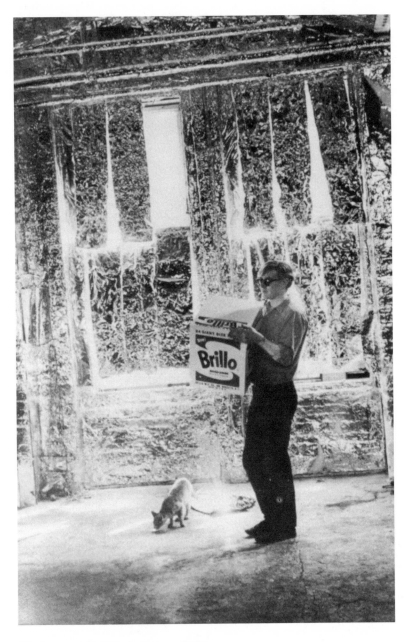

Billy Name, *Andy Warhol in the Factory,* c. 1964.

paint. To the visitor, bewildered as to the how and why of this fancy, Verlaine's reply was, "But this is how poets should live!" Grandeur, as tribute to and warrant of the artist's vocation, was not, one imagines, the point of Billy Linich's decoration of Warhol's studio walls. That would, in fact, have been distinctly at odds with the aesthetic of the tacky which prevailed in this latter-day version of bohemia. Rather, tin foil bestowed, as gold would not, the minimal reflective potential upon surfaces which could transform the Factory into a dim hall of mirrors, redoubling in its confusion of actor and audience the narcissistic dynamic of the site's theatrical economy.

Here was a factory located outside the codes and standards that govern and sustain industrial labor. To understand the old Factory is to absorb that paradox and to reconstruct a world in which the prohibitions and restrictions that determine and sustain the structures and order of production are bracketed.

We reconstruct, then, a milieu in which, as well, the prohibitions and restrictions that govern the structure and order of everyday life are suspended, together with the decorum that underwrites traditional forms of social hierarchy. From this world are excised the pity, piety, and etiquette linked to those forms. Here distances between persons are abrogated and eccentricity is exalted. Parodistic expression forms the center, the core of a continuous representation governed by a principle of inversion. Here the world is seen in reverse, as it were, or askew, or upside down. Travesty and humiliation are central tropes of representation. And through this place, from time to time, came the sound of laughter, shrill and ambivalent, both mordant and revitalizing, both aggressive and self-destructive.

Such was the milieu of the old Factory in its prelapsarian era (1960–1968), the site of Warhol's most productive period. In that world, choice, risk, transgression had lost their ground; the enveloping air breathed, sanctioned, and enabled the abolition of those interdictions that constitute their ground. The old Factory of East 47th Street was, then, in the expansionist climate of the early 1960s, preeminently the site upon which Duchamp's door of *11, rue Larrey* opened to reveal the din and clutter, the revelry and theatrics of Bakhtinian carnival, as described in the great works on Rabelais and Dostoevsky. The old Factory, the site of Warhol's recasting of the *Gesamtkunstwerk,* solicits analysis in terms of Bakhtin's master category, defined as "the sum total of all diverse festivities of the carnival type."[13]

One recalls, then, the manner in which carnival, in its most general form, is defined as syncretic pageantry of a ritualistic sort, producing vari-

ants and nuances that vary with period and with differences of cultic origin and individual festivity. Carnival has, as Bakhtin puts it, "worked out an entire language of symbolic concretely sensuous forms—from large and complex mass actions to individual gestures." And most significantly, of course, "As theatrical representation, it abolishes the dividing line between performers and spectators, since everyone becomes an active participant and everyone communes in the carnival act, which is neither contemplated nor, strictly speaking, performed; it is lived."

Within this life, several particular modalities are distinguished. Those of especial relevance to our present consideration are abolition of distance and establishment of free and familiar contact and exchange; eccentricity; *mésalliance;* and profanation. In carnival, behavior and discourse are unmoored, as it were, freed from the bonds of the social formation. Thus, in carnival, age, social status, rank, property lose their powers, have no place; familiarity of exchange is heightened.

Linked to this is the possibility of "carnivalistic *mésalliances*": "All things that were once self-enclosed, disunified, distanced . . . are drawn into carnivalistic contacts and combinations. Carnival brings together, unifies, weds, and combines the sacred with the profane, . . . the great with the insignificant, the wise with the stupid." And, of course, the high with the low.

It thus becomes that nexus within which *mésalliances* are formed. As Kathy Acker pointed out in an account of the Factory, "the uptown world of society and fashion" here joined that of prostitution and the general "riff raff of Forty-Second Street, that group which at the same time no decent person, even a hippy, would recognize as being human." It was in this social nexus that Edie Sedgewick (among other "girls of good family") enjoyed her brief celebrity. Here the hustler could play Tarzan to Jane, "sort of."

And since, in carnival, parodistic images parody one another, variously and from varying points of view, Roman parody is described as resembling "an entire system of crooked mirrors, elongating, diminishing, distorting in various directions and to various degrees." We may say that the tinfoiled studio literalized this practice. More than that, however, it was Warhol's strength to have revised the notion of the *Gesamtkunstwerk,* displacing it, redefining it as site of production, and recasting it in the mode of *carnival,* thereby generating for our time the most trenchant articulation of relation between cultures, high and low. In the picture of carnival as a system of representation, we can recognize the old Factory, that hall of mir-

rors whose virtual space generated improbable encounters, alliances, eliciting the extravagant acts, gestures, "numbers" that composed the serial parody of Hollywood production that overtakes the Warholian filmography of 1960 to 1968.

It is, however, Bakhtin's definition of the essential and defining carnivalistic act that completes and confirms one's characterization of the old Factory as carnivalistic system. That act is "*the mock crowning and subsequent decrowning of the carnival king.*" Italicizing the phrase, he insists upon its presence in all festivities of the carnival type, in the saturnalia as in European carnival and festival of fools:

> Under this ritual act of decrowning a king lies the very core of the carnival sense of the world—*the pathos of shifts and changes, of death and renewal.* Carnival is the festival of all-annihilating and all-renewing time. Thus might one express the basic concept of carnival. But we emphasize again: this is not an abstract thought but a living sense of the world, expressed in the concretely sensuous forms . . . of the ritual act.

The crowning ritual is, however, invested with a dualism, and ambivalence; its shifts celebrate the "joyful relativity of all structure and order, of all authority." For

> Crowning already contains the idea of immanent decrowning; it is ambivalent from the very start. And he who is crowned [and it is by popular demand or by election that he is so crowned] is the antipode of a real king, a slave or a jester; this act, as it were, opens and sanctifies the inside-out world of carnival. In the rituals of crowning . . . the symbols of authority that are handed over to the newly crowned king and the clothing in which he is dressed—all become ambivalent and acquire a veneer of joyful relativity; they become almost stage props. . . . From the very beginning, a decrowning glimmers through the crowning.

Bakhtin stresses the manner in which, for the medieval festival of fools, mock priests, bishops, and popes were chosen *in place of* a king. And it is, indeed, in the climactic sequence of *The Chelsea Girls* (1968), the crowning work of Warhol's significant film production, that the Factory, which generated the continuous parodistic procession of divas, queens, and "su-

perstars," produces, like the world of the medieval carnival, as its culminat-
ing ritual, its own *parodia sacra:* the election of a pope. Ondine, the virtu-
oso performer at the center of the film's most brilliantly pyrotechnical
sequence, does indeed insist that he has been *elected* pope. He comes on
with his paper bag,

> from which (with much noisy crinkling on the sound track), he ex-
> tracts a syringe. Using his belt to tie his arm, he proceeds through the
> methodical ritual of giving himself a shot of methedrine. . . . Ondine
> then turns to the camera and asks if he should begin. "Okay? Okay.
> Well now, let's see." He arranges himself more comfortably. "As you
> are all well aware, uh, I am the Pope. And, uh, the Pope has many du-
> ties. It's a crushing job. I can't tell you. And—uhhh—I've come down
> here today in order to give you all some kind of inside view of my life,
> and what I've been doing with my uhhhhh"—there is a long track-
> ing pause—"Popage? Right, my Popage. Not just the Pope as Pope,
> but the Pope as a man. Right? First of all, you will undoubtedly want
> to know who, or what, I am Pope of. Well, uhhhh," a mock faggot
> groan, running his fingers through his hair. "Jesus! There's nobody left.
> Who's left?"
>
> Time is being filled. . . . But now, back on the left, a woman walks
> on; somebody new has come to give her confession to Ondine, as In-
> grid Superstar did at the beginning of the film. As she sits down and
> begins to talk, something seems wrong, slightly off . . . somewhat
> smirkily, she sets out to question the Pope's spiritual authority. She an-
> nounces that she is hesitant to confess. Exactly Ondine's meat. "My
> dear, there is nothing you cannot say to me. Nothing. Now tell me,
> why can't you confess?" The inattentive ear hears the remark fall: "I
> can't confess to you because you're such a phony. *I'm* not trying to be
> anyone."

Ondine replies,

> "Well, let me tell you something, my dear little Miss Phony. You are a
> phony. You're a disgusting phony. May God forgive you," and Ondine
> slaps her again, more violently, then leaps up in a paroxysmic rage.
> With his open hands he begins to strike the cowering bewildered girl
> around the head and shoulders. "You goddamned phony, get the hell
> off this set. Get out."

Ondine then breaks down and

circles the room, hysterical—"I'm sorry, I just can't go on, this is just too much, I don't want to go on"—it is the longest camera movement in the film. Her husband is a loathsome fool, she is a loathsome fool, and so it goes. Phase by slow, self-justifying phase, Ondine, who has been beside himself, slowly returns to himself—that is, to the camera. And, as he calms himself, the camera reasserts its presence."[14]

Ondine's interlocutor, in questioning his papal authenticity, has transgressed the limits, violated the canon, opened a breach in the regime of carnival, the ground of Ondine's papal incarnation. If Ondine cannot go on, it is because that breach is, indeed, a grave one, involving not merely an error of style, a *faux pas*, a loss of "cool," but a radical assault upon the Factory's regime of representation and, by implication, upon its spatiotemporal axes.

The time of carnivalistic representation is that of the undifferentiated distension. This carnivalistic Factory constructed, enclosed within a world where time is indeed money, suspended, annulled, in turn, the spatio-temporality of productivity's *ratio*. Carnival time is indeed expended, not clocked or measured. Day and night succeeded each other in scarcely visible sequence within the tin-foiled precinct of the old Factory. And this was fundamental to the sense in which its production had introduced a rupture within filmic practice, as well.

The cinema of part objects, epitomized in the hyperbolic montage of Brakhage, had been that of aspiration to a continuous present, one image succeeding another at a pace that allows no space or time for recall or anticipation. The spectator is positioned within a hallucinated *now*. Warhol's films, as we know (including many who have not even seen them), generate another kind of temporality, for they take, as it were, their time, the distended time of contemplation and expectation: Robert Indiana slowly, slowly eating what appears to be a single mushroom; a man receiving a blow job; John Giorno sleeping; the light changing on the Empire State Building. That time, punctuated only by the flares of successive reel endings, is also time in which to wonder: "What's going to happen? Do I have time to go and buy some popcorn or to go to the bathroom without missing anything? How long, oh Lord, how long?" In an industrial film—say Douglas Sirk's *Written on the Wind*—the gap is not irreparable; in *Window Water Baby Moving* it is; for Brakhage's categorical rejection of the narrative

code has, in fact, as one of its primary purposes, to insure that irreparability.

Brakhage saw in Warhol's work an elimination of subjectivity. Brakhage had insisted on a preeminence of subjectivity that required a radical assault upon the space of representation, upon the radical separation of signifier and signified. Not simply the suppression of objects, actors, and actions, but the radical transformation of the spatiotemporality that was their precondition: the elision of their determinant coordinates. In his filmic perpetual present, inspired by the poetics of Gertrude Stein, images and sequences thus follow in the most rapid and hyperbolic fluidity of editing, eliminating anticipation as vector of cinematic construction. Both memory and anticipation are annulled by images as immediate and fugitive as those we call hypnagogic, that come to us in a half-waking state. Like them, Brakhage's films present a nonstop renewal of the perceptual object that resists both observation and cognition. The hypnagogic, as Sartre had noted, can excite attention and perception: "one sees something, but what one sees *is* nothing."

This is a vision that aspired to a pure presence, in which the limits separating perception and eidetic imagery dissolve in the light of vision as Revelation, uncorrupted by the Fall that is called the Renaissance, as perpetuated in the very construction of the camera lens.

Brakhage is known to have uttered a howl of rage at the emergence of Warhol's film work—largely, one surmises because *it seemed not to be work.* But surely, mainly because the old Factory regenerates, as it were, through the celebrated unblinking voyeuristic state of Warhol's camera, the time, the temporal axis of expectation along which narrative can be reinstated. What Brakhage foresaw, no doubt (with an anticipatory shudder, rather reminiscent of Eisenstein's, just three decades before, at the approach of sound), was that along the temporal axis, the narrative syntagma could be restored, and with it the space of the whole body as erotic object of narrative desire.

Warhol's parody of the film factory stands, nevertheless, as a powerful gloss on the Frankfurt School analysis of the culture industry. To reread that text is to recall to what degree it focuses upon film production as the paradigmatic mode of the culture industry, and how sharply its critique is directed at what we now see as the construction and positioning of the spectator.

For the last decade and a half, the discipline of cinema studies has worked to analyze and theorize that positioning. There is, however, a sense

in which the recent ascension of cultural studies begins to work against this theorization through its determination to valorize the spectator, now cast as resistant. (One thinks of a recent characterization of Madonna's body as the "site of semiotic struggle.") For Warhol, stars were, in Horkheimer and Adorno's phrase, "a pattern around which the world-embracing garment is cut," a pattern they warn us "to be followed by those shears of legal and economic justice with which the last projecting ends of thread are cut away." For, as they put it in the note entitled "Mass Society,"

> The opinion that the leveling-down and standardization of men is accompanied on the other hand by a heightened individuality in the "leader" personalities that corresponds to the power they enjoy, is false and an ideological pretense. [Rather, they are] focal points at which identical reactions of countless citizens intersect . . . a collective and overexaggerated projection of the powerless ego of each individual.
>
> They look like hairdressers, provincial actors, and hack journalists. Part of their moral influence consists precisely in the fact that they are powerless in themselves but deputize for all the other powerless individuals, and embody the fullness of power for them, without themselves being anything other than the vacant spaces taken up accidentally by power. They are not excepted from the break-up of individuality; all that has happened is that the disintegrated form triumphs in them and to some extent is compensated for its decomposition. The "leaders" have become what they already were in a less developed form throughout the bourgeois era: actors playing the part of leaders.[15]

It is the supposedly resistant spectator of cultural studies, "glued," as they say, to the television, who, having somehow converted the family living room into a site of resistance, elected—not once, but twice—just such an actor to the presidency of the United States of America.

Notes

1. Max Horkheimer and Theodor W. Adorno, *Dialectic of Enlightenment,* trans. John Cumming (London: Allen Lane, 1973), p. 124.

2. László Moholy-Nagy, *Painting, Photography, Film,* trans. Janet Seligman (Cambridge: MIT Press, 1969).

3. Ibid., p. 17.

4. Ibid.

5. Warhol is known to have placed the following advertisement in the *Village Voice* in 1966: "I'll endorse with my name any of the following; clothing, AC-DC, cigarettes, small tapes, sound equipment, Rock 'N Roll records, anything, film and film equipment, Food, Helium, WHIPS. Money; love and kisses Andy Warhol. EL 5–9941." This text is reproduced in Patrick S. Smith, *Andy Warhol's Art and Films* (Ann Arbor: UMI Research Press, 1986), p. 167.

6. The increasingly sublimated erotics of avant-garde film practice in the 1970s and 1980s culminates in the production of Hollis Frampton's *Poetic Justice* and Michael Snow's *This Is,* both films composed entirely of text to be read from the screen.

7. I advance this claim in "On the Eve of the Future: The Reasonable Facsimile and the Philosophical Toy," *October* 29 (Summer 1984), pp. 3–20.

8. Andrei Bely, *Petersburg,* trans. Robert Maguire and John Malmsted (Bloomington: Indiana University Press, 1978), p. 210.

9. Hanna Segal, *Melanie Klein* (New York: Viking Press, 1980), p. 46.

10. Leo Steinberg, "Jasper Johns: The First Seven Years of His Art," in *Other Criteria* (New York: Oxford University Press, 1972), p. 37.

11. Ibid.

12. Ibid., p. 52.

13. Mikhail Bakhtin, *Problems of Dostoevsky's Poetics,* trans. Caryl Emerson (Minneapolis: University of Minnesota Press, 1984), p. 122. The quotations in the following paragraph are drawn from ibid., pp. 122–124.

14. This account of the climactic sequence of *The Chelsea Girls* is drawn from Stephen Koch's exceptionally fine study, *Stargazer: Andy Warhol's World and His Films* (New York: Marion Boyers, 1985), pp. 94–96.

15. Horkheimer and Adorno, *Dialectic of Enlightenment,* pp. 236–237.

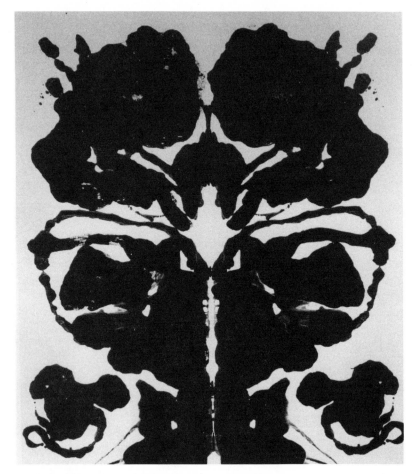

Rorschach, 1984. Synthetic polymer paint on canvas, 120 × 96 in.

Carnal Knowledge

Rosalind E. Krauss

Around the time Warhol was producing the six dozen or so of his mammoth "Rorschach" paintings, he was also putting together his book *America,* with its combination of photographs and commentary. It was in that context, in juxtaposition with a group of graveyard images, that he reflected: "I never understood why when you died, you didn't just vanish. . . . I always thought I'd like my own tombstone to be blank. No epitaph, and no name. Well, actually, I'd like it to say 'figment.'"[1]

Figment? As with the punch lines of so many other of Warhol's pronouncements, the word leaves one feeling totally unprepared. The last thing one would have expected of Andy I'd-like-to-be-a-machine Warhol is an ultimate appeal to the imaginary.

And yet, in the interview devoted to the Rorschach paintings that he gives the following year, it is indeed *figment* that he's focused on. Professing complete naiveté (as usual) about the Rorschach test's "official" status, and claiming instead, "I thought that when you go to places like hospitals they tell you to draw and make Rorschach tests. I wish I'd known there was a [standardized] set," Warhol is nonetheless entirely clear that the goal of such an image is "figment." And accordingly he says: "I was trying to do these to actually read into them and write about them, but I never really had the time to do that. So I was going to hire somebody to read into them, to pretend that it was me, so that they'd be a little more . . . interesting. Because all I would see would be a dog's face or something like a tree or a bird or a flower. Somebody else could see a lot more."[2]

That the "more" that continually forms in the eddies and pools of these symmetrical stains is insistently genital, and that the "reading" toward which any projective test is moving is phantasmatic in nature, and the nature of that fantasy usually erotic, is skirted, of course, in Warhol's own pro-

fessed limitations: his inability to read further than a tree or a bird or a flower. But this innocence is the pose Warhol liked best to assume, even while the choices taken by his studio practice continued their consistent, relentless, and articulate critique of the high art assumptions of his time.

Those assumptions were, of course, that the body could be left behind in one or another version of transcendence: spiritual, metaphysical, optical. The goal of abstract art had consistently been "purity," the sloughing off of the temporal embeddedness of existence in the assumption of a spatiality that would speak of nothing but its own autonomous self-evidence. From the moment in the early 1960s, however, that Warhol's unicolored "blanks" conducted their commercialized parody of the monochrome picture ("You see, for every large painting I do, I paint a blank canvas, the same background color. The two are designed to hang together however the owner wants. . . . It just makes them bigger and mainly makes them cost more"), the lofty vocation of abstract painting was being submitted to his strategic collapse of the difference between "high" and "low."[3]

But if the monochrome's "high" was a resistant disinterestedness countered by the "low" of per-square-foot commodification, the optical webs of Pollock's drip pictures—which became Warhol's model and target in the mid-1970s—bifurcated along the lines of the disembodied and the bodily: optical "high" versus carnal "low." The halations and bleeds of color that open across the fields of Warhol's *Oxidation* paintings have, as their reference, the vaunted miragelike emptiness of Pollock's atmospheric skeins and their supposed invention of a kind of drawing that, in enclosing nothing but "eyesight itself," leaves the viewer's body behind as a kind of discarded skin. The body is anything but left behind, however, in Warhol's scandalous interpretation of Pollock's dripped line—thrown as it was in a jet of liquid that fell onto the canvas lying prone at the artist's feet—as peeing. And it is not simply the scatological impurity of the material constituting the work—the fact that the *Oxidation* paintings were made by urinating onto canvases covered with still wet metallic paint—that challenges the purported sublimity of Pollock's art.

More profoundly, more structurally, the sublime reading of Pollock is canceled by an interpretation that refuses to reorient the work from the floor on which it was made, and thus to allow it to assume the vertical axis of the wall for which it was presumably destined, a verticality that asserts the primacy of the visual field over the other dimensions of the human sensorium, such as touch, or motion, or smell. As Freud had asserted, civi-

lization itself depends on this reorientation from the horizontal axis of the animal to the vertical one of the human, and hence from touch and smell to the mastery-at-a-distance of sight. Calling this transformation from the sexual/carnal to the rational/intellectual "sublimation," Freud's distinction already prefigures the aesthetic drive toward purity as well as the stakes involved in any regression in which there would be an axial rotation from high, or upright, to low, or horizontal. And though no one is accusing Warhol of having read Freud, the reception of Pollock in the 1960s and 1970s that focused on the transgressiveness of the horizontal implications of his dripped line ranged from Twombly to Oldenburg, from Morris to Hesse, from the Gutaï to Ruscha, and included Warhol.[4]

The Rorschach paintings are both a continuation of the logic of the *Oxidation* series and a literalization of it. For the high/low opposition that fissures these works is less about a rotation of the image out of the vertical and onto the horizontal than it is a carnal figuration that constantly threatens to erupt within the spumes and stains and bleeds of Warhol's parodic version of color field abstraction. Following on the heels of Pollock's dripped line, the "stain painting" practiced by Helen Frankenthaler and Morris Louis, or Jules Olitski and Kenneth Noland, was meant to marry the pictorial mark ever more inextricably to the weft of the canvas ground, making it ever harder to locate the embodied form of any depicted object and ever easier to perform the sublimated reading of the abstract and the optical. But by folding the stain technique into the Rorschach formula, Warhol pulls the plug on these aspirations to sublimation, reminding us that there is no form so "innocent" (or abstract) that it can ever avoid the corruption of a projective interpretation, a "seeing-in" or a "seeing-as." The doubleness of Warhol's "Rorschachs"—half stain painting, half erotic exfoliation—itself operates, then, like a projective test, or like the figures the Gestalt psychologists were fond of, where depending on whether you focused on the figure (high) or the ground (low), you either saw a vase or two opposing faces in profile.

But then, that idea of something's being riven from within, so that its very identity depends on one's point of view, one's psychological take, so to speak, in turn characterizes each half of Warhol's Rorschach structure—the high, stain painting part and the low, bodily image part. For in relation to the latter, the erotic versus the decorative ("all is pretty") implications of so many incipient vulvas and breasts and eyes and penises seem to refer one to what Freud saw as characterizing all the organs of the body in gen-

eral—that they each serve "two masters": the sexual and the self-preservative ego instincts alike. "Sexual pleasure," he wrote, "is not attached merely to the function of the genitals. The mouth serves for kissing as well as for eating and communication by speech; the eyes perceive not only alterations in the external world which are important for the preservation of life, but also characteristics of objects which lead to their being chosen as objects of love."[5] And indeed, it is this double function of the organ—its high as well as its low destiny—that makes it vulnerable to what Freud terms "psychogenic disturbance," producing it as the potential site of repression or of symptom formation, establishing it as the goal of fantasy, of "figment."[6]

And along the "high," cultural, stain painting arm of this structure, there is also an internal bifurcation, an up and a down side. For as a mark of creative individuality, the pictorial gesture is thought to be necessarily unique, nonduplicable. Indeed, it was precisely during the period of Warhol's early training and maturation that abstract expressionism came in certain quarters to be understood as the development of so many distinctive signatures: a characteristic mark as the whole of a personal style. Stain painting, as well, presupposed the individuality of the mark, the fact that there would be a significant difference between a Frankenthaler and a Louis bleed, or a Frankenthaler and a Noland spurt. And yet in the stratosphere of 1960s abstraction, the atmosphere had gotten increasingly thin, too light to support the weight of all those individual stylistic airplanes. And so difference began to be threatened by a collapse into sameness, indistinction, a gesture that was merely mechanically produced, or that anyone could do, like Warhol's imagined outpatients going to the hospital to make their Rorschachs, or like the standardized set of ten symmetrical stains into which each would project his or her own vision, his or her own "figment," his or her own phantasmatic deviation from the Same. The difference between one artist's stain and another's would seem to be threatened by this very possibility that it was nothing but a figment of some part of the art world's (the artist's? the critic's? the dealer's? the collector's?) imagination.

So if "figment" seems to be constantly lapping at the edges of the Rorschach pictures, absorbing them into its imaginary space, we need to return to the context in which Warhol himself invokes this term, the context of the graveyard, of the tombstone, and of death.

Recognizing that not a single strategy of modernist reduction, of radical negation and refusal, could escape its ultimate fate of enhancing the painting's status as object and commodity, Warhol in his use of monochromy in the early 1960s seems to have set himself the task of destroying any and all metaphysical residue of the device (be it in neoplasticist, abstract expressionist, or, as it was identified, hard edge and color field painting of the 1950s).[7]

At the conclusion of a very interesting symposium on Warhol held in 1989, Benjamin Buchloh comments on what he sees as a deep structural dilemma for any understanding of the artist. On the one hand, he says, scholarship seems to have irrefutable evidence of an obsession with death on Warhol's part, so that there is a body of his work committed to this theme, which can be read in terms very similar to that of the iconographic tradition that operates throughout Western art: terms that presuppose (1) an intentional subject and (2) a hermeneutic concept of meaning. On the other hand, there is all the rest of Warhol's work—which means, numerically speaking, the majority of it—which is totally at odds with such terms, for how, in the multiple Coca-Cola bottles, or glass labels, or cows' heads, are we to see anything but a display of the random, the arbitrary, the meaningless: of icons targeted indeed "as destructions of traditional, referential iconography"?[8] Given that both of these things seem to be true, Buchloh then asked his fellow panelists, don't we need to find a structure that would fit these two aspects together, that would make their apparent opposition make sense?

Perhaps it was the suddenness and difficulty of the question, or perhaps it was the spell that Warhol often seems to cast over his commentators who, particularly in interview situations, try to outdo him in simplicity, but Buchloh's question met a certain blankness. One response was to try to show that death could be seen to pervade even the space of the "meaningless icons"—the torn labels on some of the Campbell's soup cans, the half-full or empty condition of some of the Coca-Cola bottles—although admittedly one could not get very far with this argument. The other response was to deny that there was any problem to be solved, asserting that the two conditions could just sit side by side in the work as so many "different themes."[9]

But the death-of-the-theme is not a theme, and so it is structurally incoherent as a member of a set of "themes." And it was to this apparent structural incoherence that Buchloh was addressing himself.

116 Rosalind E. Krauss

There is, however, a structure that has always struck me as particularly revealing in relation to Warhol, and since this structure resonates both in the domain of the social and historical field (the one that includes the history of abstract art as well as that of the capitalist production of the commodity) and in that of "figment," it seems important to bring it into the present context. The structure, which René Girard calls mimetic rivalry, or metaphysical desire, rests on the notion that all desire is triangulated, which is to say, never the simple, linear relationship between two things (a desiring subject and the object that subject desires) but always three things (a subject, a mediator, and an object)—since the subject only ever desires in imitative rivalry with the mediator, desiring thus what the mediator desires.

Tracing this structure through the history of the novel, Girard takes it from the courtly forms of desire assumed by Don Quixote in imitation of his legendary heroes, forward to Proustian forms of frantic longing mediated through the complex codes of snobbery, showing how the intensification of desire seems to be a function not only of the proximity of the desiring rivals to one another but of the narrowing gap of the differences between them, such that the distinctions marked by snobbery are almost imperceptible outside the given community, but the wounds produced by their law all the more lethal. While the earlier, Quixote-type imitation is overt, and its rivalry external, the modern version is covert, hidden, inadmissible, its rivalry increasingly internal. And it is this that is important to the even more modern, mass-market, Warholian world. For as Girard remarks, "internal mediation triumphs in a universe where the differences between men are gradually erased," leaving only to abstract opposition the role of marking distinctions. But rather than decreasing rivalrous desire, this produces a situation in which "every human force is braced in a struggle that is as relentless as it is senseless, since no concrete difference or positive value is involved."[10] And in the context of postwar consumer society, Girard follows Vance Packard in pointing out that "within the American middle class more and more abstract divisions produced more and more taboos and excommunications among absolutely similar but opposed units. The individual's existence is still dominated by the Other but this Other is no longer a class oppressor as in Marxist alienation; he is the neighbor on the other side of the fence, the school friend, the professional rival. The Other becomes more and more fascinating the nearer he is to the Self."[11]

It is often said that the banalized commodity world that Warhol celebrates is the antithesis of earlier forms of individuality, the corollary of this being that the Warholian consumer is projected as a nonsubject, an extinguished flame, a being gripped by anomie. And it is this assumption of the nonsubject that constructs the half of the Warholian world devoted to the consumption series (the Campbell's soups, the dollar bills, the flowers, the cows, the famous people) as structurally incoherent with the idea of death.

But the Girardian structure of metaphysical desire tracks an increase rather than a diminution of rivalry and anguish and hatred as one moves into the logo world of abstract differences, the condition of product labels rather than substantive variation. The subject of this world is undoubtedly a subject in crisis, but it is this crisis that the structure of metaphysical desire is interested in grasping. "Like Proust's," Girard writes, "Dostoyevsky's hero dreams of absorbing and assimilating the mediator's being. He wants to become the Other and still be himself. The wish to be absorbed implies an insuperable revulsion for one's own substance, a subjectivity charged with self-hatred."[12]

Warhol's practice of seriality was not, like Carl Andre's, a repetition of the same unit, or like Donald Judd's a serial expansion of a given term. It was instead the endless insistence on the fact of difference within the same—each Campbell's soup can containing a different flavor; each Liz or Jackie or Holly Solomon an identical photo screened onto a slightly differently treated colored ground such that chimerical variations of "expression" seem to appear—now the mouth is open, now it is a closed blur of lipstick; now the eyes are sleepily hooded, now vacantly staring. These differences are of course minute, so tiny that they can be thought to be projections on the part of the viewer, nothing really objective, but merely "figments."

That the monolithic world of the commodity is not psychologically flat but rather psychologically intense, questing for difference and burning with self-hatred, no matter how hidden, is what ultimately opens this structure to the presence of death. And it is the psychological, the "figment" that Warhol allows himself to hail openly in the series called Rorschach.

Notes

1. Andy Warhol, *America* (New York: Harper & Row, 1985), pp. 126–129.

2. Robert Nickas, "Andy Warhol's *Rorschach Test,*" *Arts Magazine* (October 1986): 28.

3. As cited by Benjamin Buchloh in his analysis of this implicit critique by Warhol of the monochrome's supposed resistance to the commodification of art. Buchloh, "Andy Warhol's One-Dimensional Art: 1956–1966," reprinted in this volume, p. 19.

4. See chapter 6 of my *The Optical Unconscious* (Cambridge: MIT Press, 1993).

5. Sigmund Freud, "Psychogenic Disturbance of Vision," in *The Standard Edition of the Complete Psychological Works of Sigmund Freud,* 24 vols., ed. James Strachey (London: Hogarth Press and the Institute for Psycho-Analysis, 1953–1973), 11:216.

6. For a discussion of the implications of this double function of the organs for an understanding of Georges Bataille's concept of "base materialism," see Yve-Alain Bois's article "Bas matérialisme," in Yve-Alain Bois and Rosalind Krauss, *L'Informe: mode d'emploi,* exh. cat. (Paris: Centre Georges Pompidou, 1996), pp. 49–60. For the general importance of the double structure in Bataille, see Denis Hollier, *Against Architecture,* trans. Betsy Wing (Cambridge: MIT Press, 1989), pp. 74–173 passim.

7. Buchloh, "Andy Warhol's One-Dimensional Art," reprinted in this volume, p. 18.

8. In Gary Garrels, ed., *The Work of Andy Warhol* (Seattle: Bay Press, 1989), p. 124. For the death theme, Buchloh was referring to Trevor Fairbrother's paper in the symposium, "Skulls," as well as to an earlier essay by Thomas Crow, "Saturday Disasters: Trace and Reference in Early Warhol," *Art in America* 75 (May 1987), reprinted in this volume.

9. Garrels, ed., *The Work of Andy Warhol,* p. 126. This was Rainer Crone's position. It was Fairbrother who tried to expand the thematic of death.

10. René Girard, *Deceit, Desire and the Novel,* trans. Yvonne Freccero (Baltimore: Johns Hopkins University Press, 1965), pp. 16, 137.

11. Ibid., p. 222.

12. Ibid., p. 54.

An Interview with Andy Warhol

Benjamin H. D. Buchloh

BENJAMIN BUCHLOH I am currently doing research on the reception of Dada and Duchamp's work in the late 1950s, and I would like to go a bit into that history. I read, I think in Stephen Koch's book, that in the mid-sixties you were working on a movie project on or with Duchamp which apparently has never been released. Was it actually a project?

ANDY WARHOL No, it was just an idea. I mean, I shot some pictures, but not really. They're just little sixteen-millimeters. But the project only would have happened if we had been successful at finding somebody, or a foundation, to pay for it. Since I was doing these twenty-four-hour movies, I thought that it would have been great to photograph him for twenty-four hours.

BUCHLOH You knew him well enough at the time to have been able to do it?

WARHOL Not well enough, but it would have been something he would have done. We just were trying to get somebody to pay for it, like just for the filming, and to do it for twenty-four hours, and that would have been great.

BUCHLOH So it never came about?

WARHOL No. I didn't know him that well; I didn't know him as well as Jasper Johns or Rauschenberg did. They knew him really well.

BUCHLOH But you had some contact with him?

WARHOL Well, yeah, we saw him a lot, a little bit. He was around. I didn't know he was that famous or anything like that.

BUCHLOH At that time, the late fifties and early sixties, he was still a relatively secret cult figure who just lived here.

WARHOL Even people like Barney Newman and all those people, Jackson Pollock and Franz Kline, they were not well known.

BUCHLOH In retrospect, it sometimes seems unbelievable that the reception process of Duchamp's work should have taken so long.

WARHOL But some people like Rauschenberg went to that great school called Black Mountain College, so they were aware of him.

BUCHLOH So you think that it was through John Cage that the Duchamp reception was really generated? One of the phenomena that has always interested me in your work is the onset of serialization. Your first paintings, such as *Popeye* or *Dick Tracy,* are still single images of readymades, and it seems that by 1961–1962 you changed into a mode of serial repetition.

WARHOL I guess it happened because I . . . I don't know. Everybody was finding a different thing. I had done the comic strips, and then I saw Roy Lichtenstein's little dots, and they were so perfect. So I thought I could not do the comic strips, because he did them so well. So I just started other things.

BUCHLOH Had you seen accumulations by Arman at that time? He had just begun his serial repetitions of similar or identical readymade objects a few years before, and that seems such a strange coincidence.

WARHOL No, well, I didn't think that way. I didn't. I wasn't thinking of anything. I was looking for a thing. But then I did a dollar bill, and then I cut it up by hand. But you weren't allowed to do dollar bills that looked like dollar bills, so you couldn't do a silkscreen. Then I thought, well how do you do these things? The dollar bill I did was like a silkscreen, you know; it was commercial—I did it myself. And then somebody said that you can do it photographically—you know, they can just do it, put a photograph on a screen—so that's when I did my first photograph, then from there, that's how it happened.

BUCHLOH But how did you start serial repetition as a formal structure?

WARHOL Well, I mean, I just made one screen and repeated it over and over again. But I was doing the reproduction of the thing, of the Coca-Cola bottles and the dollar bills.

BUCHLOH That was in 1962. So it had nothing to do with a general concern for seriality? It was not coming out of John Cage and concepts of musical seriality; those were not issues you were involved with at the time?

WARHOL When I was a kid, you know, John Cage came—I guess I met him when I was fifteen or something like that—but I didn't know he did serial things. You mean . . . but I didn't know about music.

BUCHLOH Serial form had become increasingly important in the early 1960s, and it coincided historically with the introduction of serial structures in your work. This aspect has never really been discussed.

WARHOL I don't know. I made a mistake. I should have just done the *Campbell's Soups* and kept on doing them. Because then, after a while, I did like some people, like, you know, the guy who just does the squares, what's his name? The German—he died a couple of years ago; he does the squares— Albers. I liked him; I like his work a lot.

BUCHLOH When you did the Ferus Gallery show in Los Angeles, where you showed the thirty-three almost identical *Campbell's Soup* paintings, did you know at that time about Yves Klein's 1957 show in Milan, where he had exhibited the eleven blue paintings that were all identical in size, but all different in price?

WARHOL No, he didn't show them in New York until much later. No, I didn't know about it. But didn't he have different-sized pictures and stuff like that? But then Rauschenberg did all-black paintings before that. And then before Albers, the person I really like, the other person who did black-on-black paintings.

BUCHLOH You are thinking of Ad Reinhardt's paintings?

WARHOL Right. Was he working before Albers?

BUCHLOH Well, they were working more or less simultaneously and independently of each other, even though Albers started earlier. There is another question concerning the reception process that I'm trying to clarify. People have speculated about the origins of your early linear drawing style, whether it comes more out of Matisse, or had been influenced by Cocteau, or came right out of Ben Shahn. I was always surprised that they never really looked at Man Ray, for example, or Picabia. Were they a factor in your drawings of the late 1950s, or did you think of your work at that time as totally commercial?

WARHOL Yeah, it was just commercial art.

BUCHLOH So your introduction to the work of Francis Picabia through Philip Pearlstein took place much later?

WARHOL I didn't even know who that person was.

BUCHLOH And you would not have been aware of Man Ray's drawings until the sixties?

WARHOL Well, when I did know Man Ray, he was just a photographer, I guess. I still don't know the drawings, really.

BUCHLOH His is a very linear, elegant, bland drawing style. The whole New York Dada tradition has had a very peculiar drawing style, and I think your drawings from the late fifties are much closer to New York Dada than to Matisse.

WARHOL Well, I worked that way because I like to trace, and that was the reason, just tracing outlines of photographs.

BUCHLOH That is, of course, very similar to the approach to drawing that Picabia took in his engineering drawings of the mechanical phase around 1916. I wasn't quite sure to what degree that kind of information would have been communicated to you through your friend Philip Pearlstein, who had, after all, written a thesis on Picabia.

WARHOL When I came to New York, I went directly into commercial art, and Philip wanted to, too. But he had a really hard time with it, so he kept up with his paintings. And then, I didn't know much about galleries, and Philip did take me to some galleries, and then he went into some more serious art. I guess if I had thought art was that simple, I probably would have gone into gallery art rather than commercial, but I like commercial. Commercial art at that time was so hard because photography had really taken over, and all of the illustrators were going out of business really fast.

BUCHLOH What has really struck me in the last few years is that whenever I see new works of yours, they seem to be extremely topical. For example, the paintings that you sent to the Zeitgeist show in Berlin depicted the fascist light architecture of Rudolf Speer. When—at the height of neo-expressionism—you sent paintings to Documenta in Germany, they were the *Oxidation* paintings. Then, slightly later, I saw the *Rorschach* diptych at Castelli's. All of these paintings have a very specific topicality in that they

relate very precisely to current issues in art-making, but they're not participating in any of them.

In the same way, to give another example, your series of de Chirico paintings is not really part of the contemporary movement that borrows from de Chirico; it seems to be part of that, and yet it distances itself at the same time. Nevertheless the paintings are perceived as though they were part of the same celebration and rediscovery of late de Chirico. Is this critical distance an essential feature that you emphasize, or does the misunderstanding of the work as being part of the same attitude bother you? Or is the ambiguity precisely the desired result?

WARHOL No, well, I don't know. Each idea was just something to do. I was just trying to do newer ideas and stuff like that. I never actually had a show in New York with any of those ideas. No, well, I don't know. I've become a commercial artist again, so I just have to do portraits and stuff like that. You know, you start a new business, and to keep the business going, you have to keep getting involved.

BUCHLOH Vincent Fremont just mentioned that you got a number of commissions going for corporate paintings. That's very interesting because, in a way, it leads back to the commercial origins of your work.

WARHOL Well, I don't mean that, I mean doing portraits, that sort of thing. Because, I don't know, now I see the kids just paint whatever they paint, and then they sell it like the way I used to do it. Everything is sort of easier now, but you have to do it on and on. So those other things were just things that I started doing and doing on my own.

BUCHLOH So do you still make a distinction between commercial commissions and what you call the "other things"?

WARHOL Yes. The next idea for a show I have here is going to be called "The Worst of Warhol"—if I ever have my way with Paige [Powell], this girl in our advertising department at *Interview*. So it would just be all of those things, you know, the little paintings. Except most of those things were supposed to be in that show, but then they got a little bit bigger, and then everybody always . . . I sort of like the idea. The Rorschach is a good idea, and doing it just means that I have to spend some time writing down what I see in the Rorschach. That would make it more interesting, if I could write down everything I read.

BUCHLOH Yes, but aren't they also commenting in a way on the current state of painting, in the same manner that the *Oxidation* paintings are extremely funny, poignant statements on what is currently going on in the general return to painterly expressivity and technique?

WARHOL Oh, I like all paintings; it's just amazing that it keeps, you know, going on. And the way new things happen and stuff.

BUCHLOH But don't you think that there is a different attitude toward technique in the *Oxidation* paintings or in the *Rorschach* paintings? They don't celebrate technique; if anything, they celebrate the opposite.

WARHOL No, I know, but they had technique too. If I had asked someone to do an *Oxidation* painting, and they just wouldn't think about it, it would just be a mess. Then I did it myself—and it's just too much work—and you try to figure out a good design. And sometimes they would turn green, and sometimes they wouldn't; they would just turn black or something. And then I realized why they dripped—there were just too many puddles, and there should have been less. In the hot light, the crystals just dripped and ran down.

BUCHLOH That's a different definition of technique.

WARHOL Doing the *Rorschach* paintings was the same way. Throwing paint on, it could just be a blob. So maybe they're better because I was trying to do them and then look at them and see what I could read into them.

BUCHLOH So the shift that has occurred in the last five years has not at all bothered you? The return to figuration, the return to manual painting procedures—that's nothing that you see in conflict with your own work and its history?

WARHOL No, because I'm doing the same . . . If only I had stayed with doing the *Campbell's Soup* well, because everybody only does one painting anyway. Doing it whenever you need money is a really good idea, just that one painting over and over again, which is what everybody remembers you for anyway.

BUCHLOH The fact that people are now pretending again that painting is something that is very creative and skillfully executed and depends on an artist's competence—I mean the reversal of all the sixties' ideas that has taken place—you do not consider that to be a problem at all? Because the statements I see in your recent paintings seem to distance themselves from

all that. In fact, the *Oxidation* paintings or the *Rorschach* paintings seem very polemical.

WARHOL No, but at that time they would have fit in with the conceptual paintings or something like that.

BUCHLOH It's too bad that the *Oxidation* paintings weren't shown in New York.

WARHOL Well, when I showed them in Paris, the hot lights made them melt again; it's very weird when they drip down. They looked like real drippy paintings; they never stopped dripping because the lights were so hot. Then you can understand why those holy pictures cry all the time—it must have something to do with the material that they were painted on, or something like that. They look sort of interesting. I guess I have to go back to them. But the thing I was really trying to work on was the invisible painting, the invisible sculpture that I was working on. Did you go see the show at Area?

BUCHLOH No, not yet.

WARHOL Disco art? You haven't done disco art yet? Really good art—you should see it. It's going to be over soon. A lot of work by about thirty artists; it's really interesting.

BUCHLOH What did you do at Area?

WARHOL The invisible sculpture, but it's not really the way I had planned it. I've been working on it with the electronic things that make noises go off when you go into an area. But this one down here, it's just something or nothing on a pedestal. But Arman has a beautiful bicycle piece down there at Area. It filled one whole window, one whole window filled with bicycles. It's really beautiful. I think he's such a great artist.

BUCHLOH So you are aware of his work later on, just not in that early moment of the early 1960s accumulations. And you think that the early work is interesting as well, the work from the late fifties and the repetition of the readymade objects?

WARHOL Yes, well, that's what he always does.

BUCHLOH The earlier ones are more direct and poignant than the later work, which is kind of aestheticized.

WARHOL The earlier ones I saw were like a car. What was that, a cop car or something?

BUCHLOH He put a package of dynamite under a car, a white MG, and blew it up. There was a collector in Düsseldorf, an advertising man who gave him a commission to do a work. So Arman said, "OK, Charles Wilp, give me your white MG car," and blew it up. It's called *White Orchid*—it's a wonderful piece.

WARHOL But his work now is really great.

BUCHLOH I would be interested in discussing how you saw the subsequent development in the 1960s with the rise of minimal and conceptual art, before the rather rapid inversion of all of these ideas in the early 1980s. Do you have any particular relation to those artists that came out of conceptual art? Did you follow up on these issues? Do the nonpainterly artists who are now working interest you as much as the painters do?

WARHOL Yes, but there are not many. There are [fewer] conceptual artists around now for some reason.

BUCHLOH But at the time when conceptual art was done—people like Lawrence Weiner, for example—does that kind of work interest you?

WARHOL Yeah, that was great. But are they still working? Are they doing the same thing?

BUCHLOH Yes, they're still working; they've continued to develop these approaches. In public, you seem to support painting more than anything else.

WARHOL Oh no, I love that work. They're all great.

BUCHLOH So you don't see painting now as contrary to your own work.

WARHOL Nowadays, with so many galleries and stuff, you can just be anything. It doesn't matter anymore; everybody has taste or something like that. There are so many galleries. Every day a new one opens up, so there's room for everybody. It's amazing that you can go in every category and it's just as good, and just as expensive.

BUCHLOH So you don't attach any particular importance to one principle any longer? In the sixties, there was a strong belief system attached to the art.

WARHOL In the sixties everything changed so fast. First it was pop, and then

they gave it different names, like conceptual art. They made it sound like it was modern art or something because it changed so fast, so I don't know whether pop art was part of that, or whether it was something else, because it happened so fast.

BUCHLOH But the question of the original, for example—the artist as an author, as an inventor, or as somebody who manufactures precious objects—was a question that was really criticized in the sixties. You were always the central figure in these debates, or at least you were perceived as the central figure who had criticized that notion in the same way that Duchamp had criticized it. And now things have turned around, and now it seems that this is no longer an issue at all.

WARHOL Certainly I would like to think that I could only work that way. But then you can think one way, but you don't really do it; you can think about not drinking, but you drink, or something like that. And then I hear about this kind of painting machine a kid just did, and then I fantasize that it would be such a great machine. But, you know, Tinguely did one sort of like that.

BUCHLOH Yes, in the late 1950s, at the height of tachism, when it became too absurd.

WARHOL I still think there is another way of doing that painting machine. This kid has done it, but it falls apart. But I really think you could have a machine that paints all day long for you and do it really well, and you could do something else instead, and you could turn out really wonderful canvases. But it's like . . . I don't know, this morning I went to the handbag district, and there were people that spend all day just putting in rhinestones with their hands, which is just amazing, that they do everything by hand. It would be different if some machine did it . . . Have you been going to galleries and seeing all the new things?

BUCHLOH Yes, I go fairly consistently, and I have never really quite understood why everything has been turned around in that way, why all of a sudden people start looking at paintings again as if certain things never happened.

WARHOL It's like in the sixties when we met our first drag queens, and they thought they were the first to do it. Now I go to a party and these little kids have become drag queens. They think they are the only people who

ever thought of being a drag queen, which is sort of weird. It's like they invented it, and it's all new again, so it makes it really interesting.

BUCHLOH Are your TV program and your paintings, then, in a sense the extreme opposite poles of your activities as an artist?

WARHOL Yes, we are trying to do two things, but the painting is really exciting. I don't know, I'm just really excited about all the kids coming up, like Keith Haring and Jean-Michel [Basquiat] and Kenny Scharf. The Italians and Germans are pretty good, but the French aren't as good. But like you were saying about Yves Klein and stuff being . . . But the French do really have one good painter, I mean, my favorite artist would be the last big artist in Paris. What's his name?

BUCHLOH A painter?

WARHOL Yes, the last famous painter. Buffet.

BUCHLOH Many of the new painters seem to imitate him anyway.

WARHOL Well, I don't know, I don't see any difference between that and Giacometti. Somewhere along the line, people decided that it was commercial or whatever it was. But he's still painting, and I still see the things; the prices are still $20,000 to $30,000. He could still be there. His work is good; his technique is really good; he's as good as the other French guy who just died a couple of days ago, Dubuffet. What do you think has happened? Do you think it is not that good?

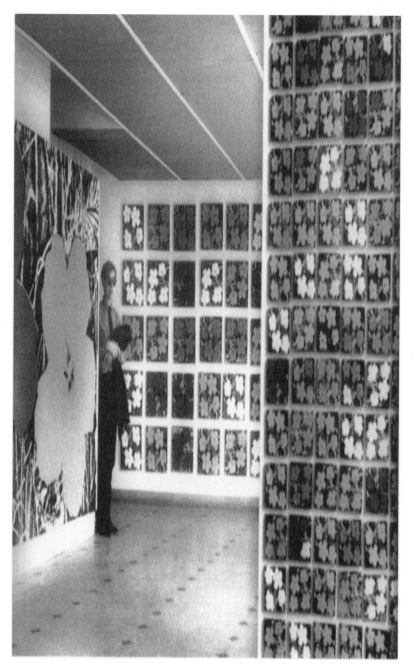

Installation view, Galerie Ileana Sonnabend, Paris, 1965.

Index of Names